PEMBROKE
& AROUND
THROUGH TIME
Nikki Anderson

AMBERLEY PUBLISHING

About the Author

Nikki Anderson moved to Pembroke in 1972 and fell in love with the unique, friendly little town with its big history. Now retired, she helps co-ordinate the Pembroke Story project, originally funded with help from the Heritage Lottery and for the last three years run entirely by volunteers through the Community Association, 21C.

If you would like to learn more about Pembroke and its people, visit the Pembroke Story website at www.pembrokestory.org.uk.

About the Photographer

Gwen Griffiths moved to Pembroke with her husband Brian and young children in the 1960s. Throughout the years she has photographed all aspects of Pembroke life, its people and its buildings, creating a valuable record of events and change.

First published, 2013

Amberley Publishing
The Hill, Stroud, Gloucestershire, GL5 4EP
www.amberley-books.com

Copyright © Nikki Anderson, 2013

The right of Nikki Anderson to be identified as the Author of this work has been asserted in accordance with the Copyrights, Designs and Patents Act 1988.

ISBN 978 1 4456 1612 4 (print)
ISBN 978 1 4456 1627 8 (ebook)

British Library Cataloguing in Publication Data.
A catalogue record for this book is available from the British Library.

Typesetting by Amberley Publishing.
Printed in Great Britain.

Introduction

The sleepy town of Pembroke lies at the south-western tip of Pembrokeshire in south-west Wales, and is laid out along a rocky limestone outcrop.

Within the old town walls, Pembroke's Main Street runs a little over half a mile from east to west, where the great medieval gates into the town once stood.

Most of the town's properties today, lying within the walls, are Georgian or Victorian and are arranged down a single 'main' street with long, narrow gardens (burgage plots) stretching down to the old medieval walls that are built along the Mill Pond to the north and the Pembroke Commons on the south.

At the western end, Pembroke is dominated by a magnificent Norman Castle with its imposing towers and 100-foot-high keep. There is a dungeon within, and a huge cave – Wogan's Cavern – below, which is reached down carved stone steps from the castle above, and was thought to have been a boathouse and access into the castle over a thousand years ago. At one time, the town and castle would have been almost surrounded by water, lying as they do at the end of a tidal inlet of the Milford Haven Estuary, and for centuries the town's prosperity revolved around the quays and sea trade.

The Pembroke story encompasses everything from French-speaking lords, to the fascinating and influential Princess Nest, and a young mother who gave birth to the future King Henry VII, founder of the Tudor Dynasty. Saints and hermits lived nearby and the Knights Templar founded mills to help fund the Crusades. Oliver Cromwell came, laid siege, and conquered, and John Wesley returned many times to preach his sermons to all who would listen. Other visitors included Daniel Defoe and artist J. M. W. Turner.

The Black Death greatly reduced the population and the town's fortunes have fluctuated through time. By the eighteenth century,

however, the rise of the important local families of Owen, Meyrick, and Adams, and the marriage of Elizabeth Lort to the Scottish Lord Cawdor, resulted in a time of prosperity, fine housebuilding and the development of grand estates, which needed a large workforce to manage the land, livestock, gardens, stables and all that went with grand living. Georgian houses were built in Main Street as town houses, the coaching inns thrived, and estate and farm workers were hired at the Pembroke Hiring Fairs. Pembroke is one of the few towns left in the UK that still has its October Fair, set up along the East End of Main Street, with the road closed for part of that time.

In the 1960s the town benefited from the influence of oil, and today it exists as 'the Gateway' to the spectacular south Pembrokeshire coast with its fine beaches, cliff walks, surfing, and delights just waiting to be discovered.

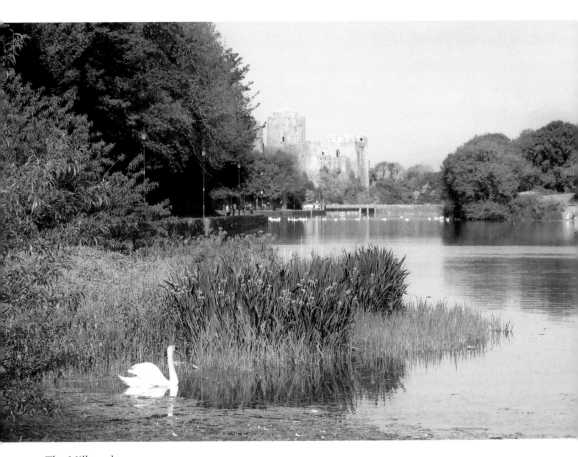

The Millpond.

Acknowledgements

Huge thanks are due, firstly, to Gwen Griffiths for her tireless work in obtaining the modern photographs.

A special thank you is also due to Jean Hambly, Ben Manning and John Rolls for their help and support.

I am grateful to Pembroke Community Association for their contribution, and to the members of Tabernacle Chapel for the use of their facilities.

I must also thank the following people, who have all helped in a variety of ways:

Keith Johnson, Tony Thomas, Carol Jenkins, John Hogg, Pat Lewis, the Colley family, Kath Levell, Peter Hurlow-Jones, Dave Harries, Judy and St John Stimson, Mary Williams, George Palmer, Rosemary Bevan, Steven Devote, David Griffiths, Sid Howells, Pam Rendall, Eric Robinson, Harold Thomas, Sheila Prout, Lisa Hellier, Gweneira Maillard, Edward Harries, Eunice Williams, Ceri Addis, John Hardwick, Irena Kruszona (and John), Ron Watts.

I am also grateful to Francis Frith, JS Valentine, Barton, CS Allen, Squibbs, Harvey and others for the use of their postcards.

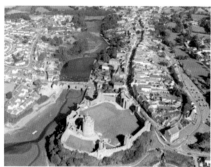

Pembroke from the east and the west. (Sid Howells)

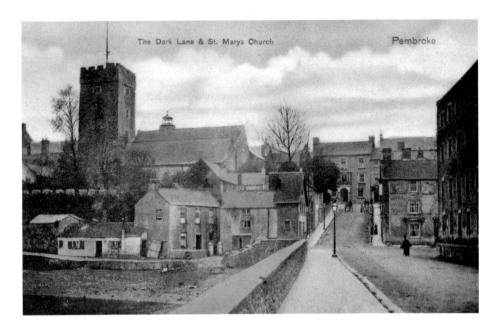

The Dark Lane & St. Marys Church Pembroke

Old Mill Bridge

The Great North Gate and the old mill have gone – the rest of the scene is instantly recognisable and little changed in a hundred years. With the castle established by Roger de Montgomery, William the Conqueror's right-hand man in 1093, successive kings granted Pembroke Borough status and royal charters (special lists of rights) to encourage status and growth by allowing markets and fairs, and also stating that all cargo ships coming into the Haven had to come to 'the bridge at Pembroke' to trade. The first mill was built around 1199, and corn continued to be milled on the bridge for 750 years, until the last mill burnt down in 1955. Blacksmiths were also essential – the equivalent of today's car tyre trade – and the smithy seen above on the left belonged to Dick Williams. Seen above the smithy, the crenelated section of old town wall has now disappeared. Pembroke has a newly formed Town Walls Trust with the aim of making good the entire oval of the town's walls.

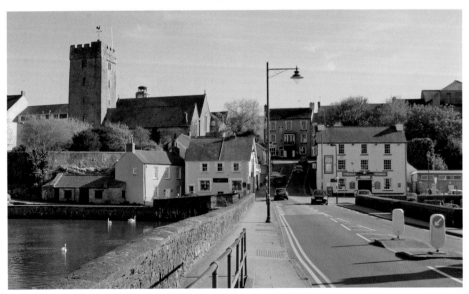

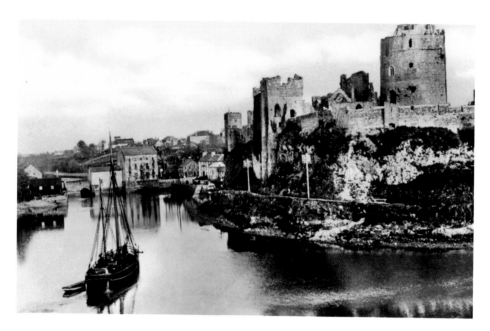

This is Where it All Began

When the Normans arrived in 1093, they would have sailed up the Milford Haven to this arm of the estuary, where the dominating limestone outcrop, surrounded on both sides by tidal waters, was there to greet them. Norman knight Gerald de Windsor was appointed keeper of the castle for his Norman overlord, Arnolf de Montgomery (Roger's son), and in an arranged marriage became the husband of fabled Welsh Princess Nest. Nest had a son by Henry I, having been taken hostage by the Normans when her father, the last Welsh king, Rhys ap Tewdwr, was killed in battle. That first fortification would have been a wooden affair with a ditch on the landward side – sufficient to ensure that Welsh attacks were unsuccessful.

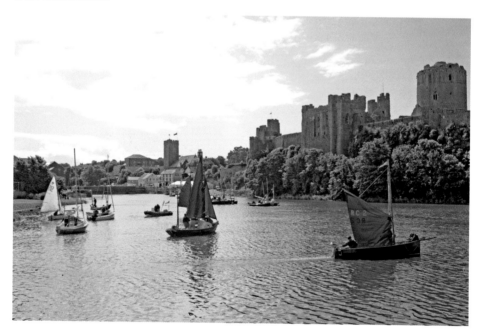

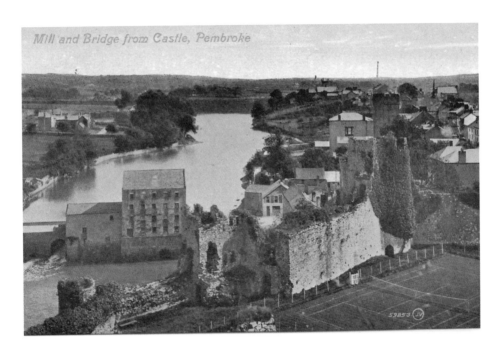

The Castle in Ruins

Having withstood attack from the Welsh and the rise and fall of fortunes through the years, in 1457 Pembroke Castle became the birthplace of the great future king, Henry Tudor. Lady Margaret Beaufort, his mother, was only thirteen when she gave birth, her marriage having been arranged a year before to Edmond Tudor. Henry went on to become King Henry VII after defeating Richard in the Wars of the Roses and marrying Elizabeth of York, thus founding the Tudor dynasty. It was not until Oliver Cromwell and his army came to Pembroke in 1648 that the castle, for the first and last time, was destroyed. Cromwell took the castle after a seven-week siege and ordered it to be destroyed with the aid of gunpowder technology.

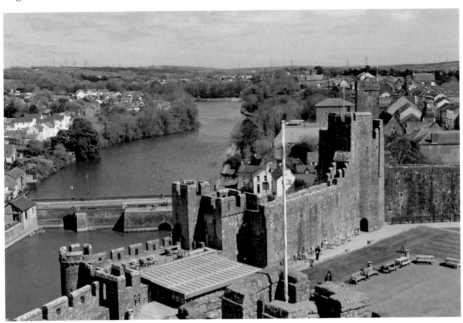

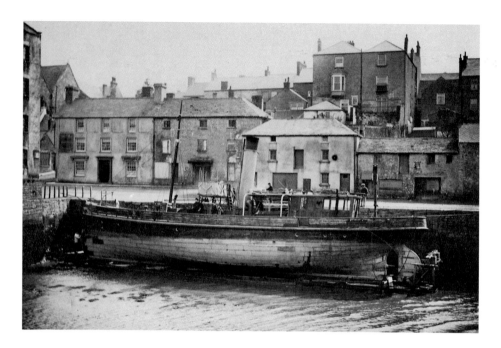

The South Quay

Rebuilt and modernised in 1818, the success of South Quay trade was reflected in the high number of public houses in the near vicinity. The great North Gate of the town was situated at the foot of the steep Dark Lane above at the side of the Royal George. Of the twenty-four so pubs trading in the town, the George is one of the oldest still trading. The boat is a fine example of the five or six ships that traded regularly in a 'triangle' between Pembroke, Devon and Ireland. The best remembered is probably the *Kathleen and May*, and others included the *Garlandstone*, *Arcacia* and the *Mary Jane Lewis* – eventually wrecked on rocks at Angle 10 miles away.

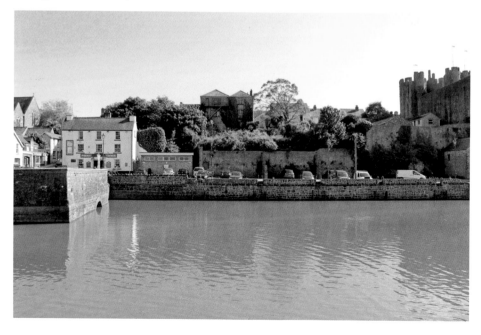

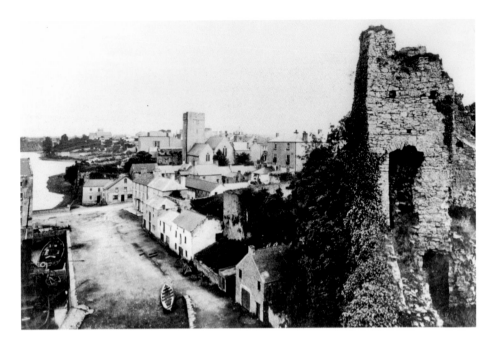

Looking Down to the Quay, 1890

This view of the South Quay shows a time when all the buildings below appear to be in use, and the castle lies in ruins. In the distance, the Millpond still empties with the low tide (no barrage preventing the seawaters from coming up to the castle in those days), and the Mill Bridge does not appear to have any walls. The height of the impregnable castle above sea level is a reminder that Pembroke Castle was never taken. It came close once or twice, however, including the year 1096 shortly after Gerald de Windsor had been installed as castle keeper. The Normans had hastily put up a timber fortification, and when a serious attempt to attack and starve out the army was made, it is written that Gerald ordered his soldiers to throw sides of bacon over the wall to trick the Welsh into thinking that there was still a good supply of fresh food within the castle.

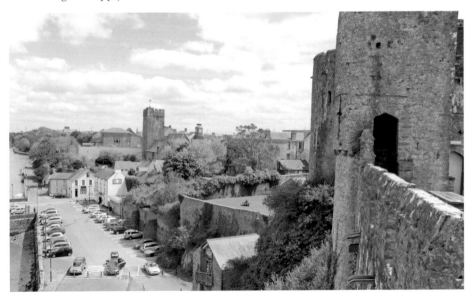

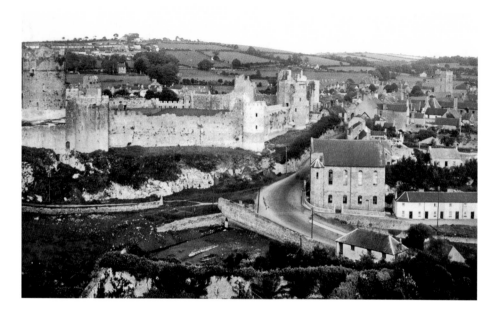

Looking East

Taken from the south-west, this view shows the massive rock upon which Pembroke Castle is built. The West Gate was situated just above the chapel, and on the ledge below the castle wall was a row of 'mean dwellings'. The impressive Calvanistic chapel replaced the original Bethel chapel of 1826. It was built in 1867, in an era of distinct rivalry in grand chapel building, with others including the imposing Gothic tabernacle, Italianate Wesley chapel, and Bethany up on East Back. When navvies arrived from North Wales to help build the new railway, Welsh-speaking services were organised. The terrace of ten white cottages was called Bankers Row, supposedly built as an investment by two bankers. Though only 'two up one down', many were home to large families such as the couple and their nine children and, further up, a widow and her six children.

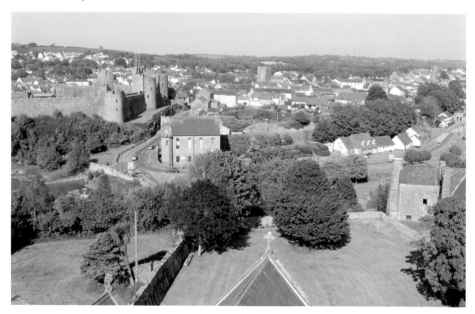

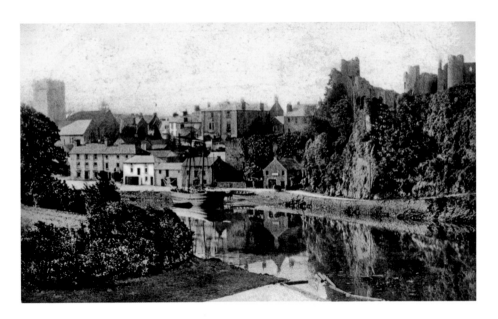

A Favourite View

This lovely tinted Valentine postcard shows a classic view across the water to Pembroke Castle and quay. From the 1880s, the popularity of picture postcards increased and there was a 'golden age' from the turn of the century until the beginning of the First World War. Pembroke photographers included Frank Stern, who came from Cambridge and set up his business, Cambridge Studios, in Main Street. Austin Sayse Lewis also photographed Pembroke views extensively, and in Pembroke Dock there was S. J. Allen, William & Sarah Trindall, and Arthur Squibbs. On the quay, one of the best-remembered characters was Harry Davies, whose father had set up as a wheelwright and coachbuilder at the top of the slipway. Harry was not only a good wheelwright, but also a popular carpenter and undertaker, and could boast that he and his apprentice had made the biggest wheel ever made in Pembrokeshire – it was 6 feet in diameter.

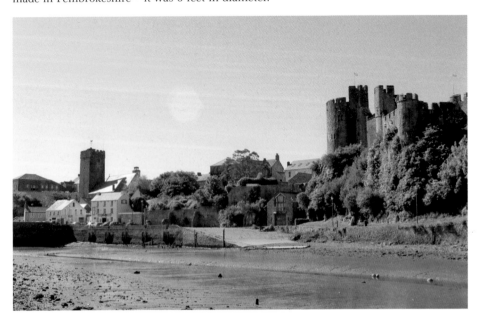

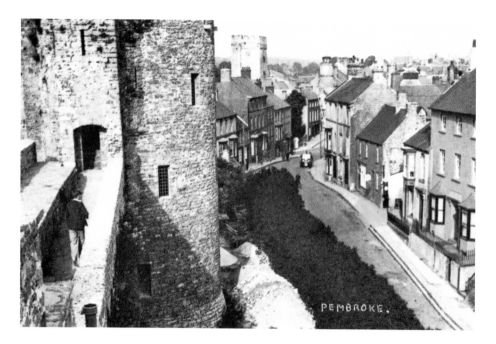

Looking Down to Castle View

This scene looks down from the Henry VII tower in Pembroke Castle. The three-storey house on the right was the vicarage for the town's two parishes – St Mary's and St Michael's. In the early part of the twentieth century, an early garage with petrol pump was established opposite the entrance to the castle by Mr Owen Davies, and as road transport expanded after the Second World War one of the older properties there was demolished and a car salesroom was built. Peters Motors took over, but eventually traffic on the hill became so busy that the site was impractical. With its proximity to the quays, the large three-storey building owned by the George family was in existence as far back as 1790 as a brewery and corn merchant's business, but parts of the building are probably much older.

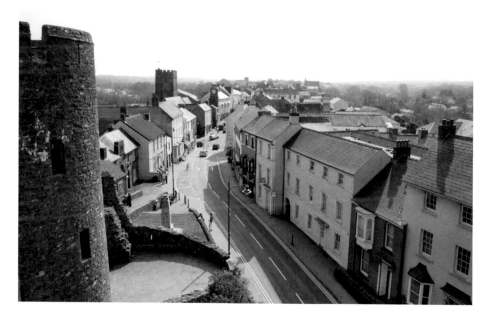

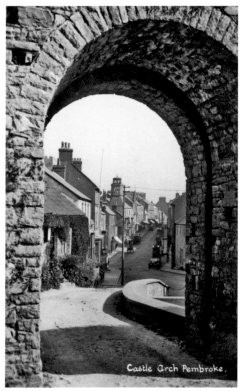

Castle Arch Pembroke.

A Glimpse Through the Arch

Renovation of the castle was completed by Sir Ivor Phillips by 1935, and the cottage by the castle entrance seen in the postcard on the left belonged to a Mr Steadman, a caretaker. It had taken ten men over seven years to complete, with Mr Steadman as their foreman. The Territorial Army Drill Hall, set back from the road and through an arch created by demolishing No. 8 Castle Terrace, for many years had a First World War cannon outside – it can be glimpsed on several early postcards. The Servicemen's Club was situated in No. 5 and was only closed when the local authority bought several houses in the terrace for 'redevelopment'.

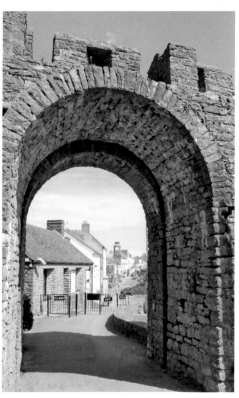

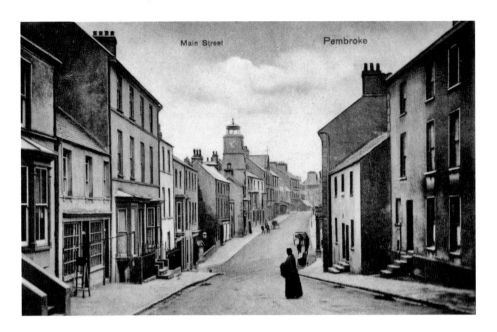

Steps Down to Main Street

Where the Long Entry Car Park is situated today, a passage or 'drang' ran from Main Street through to The Parade, with a row of twelve one-roomed cottages on either side. The cottages were occupied by the poor and entry was up the steps and through doors in either No. 2 or 3 Westgate, as seen in the postcard above. Like Bankers Row, some of the 'lean-to' hovels were occupied by large families, but also elderly widows who had fallen on hard times. At the far end of the drang, a door led out onto The Parade and had originally been the Postern Gate where travellers could access the town when the North, West or East Gates were locked for the night. Adjacent to Long Entry, the large three-storey building belonged to Robert George & Son, wine and spirit merchant. The Cromwell Brewery there was taken over by the Swansea Old Brewery and in 1928 became Hancock's Brewery. It has a new lease of life today as a Haven Christian Centre, with a courtyard café.

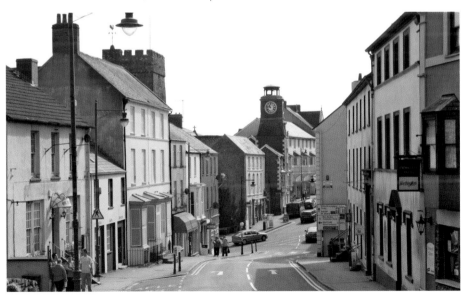

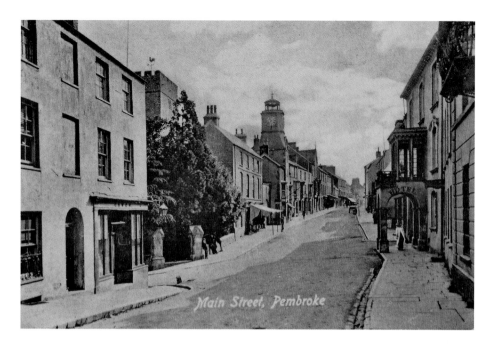

Main Street, Pembroke

The Top of Dark Lane

Until the town's enhancements in 1818, there were two more narrow houses on the corner at the top of the Dark Lane – known officially as Northgate Street. That house, and others on the east side of the hill, were removed to improve conditions for horses and carts; there was a huge increase in traffic with the development of Pembroke Dock. This photograph was taken around the turn of the century and before Pannell's Furniture Removers occupied the premises on the west corner of Darklin – North Gate House. Their sign on the end of the building used to read 'Keep Moving – we like it'.

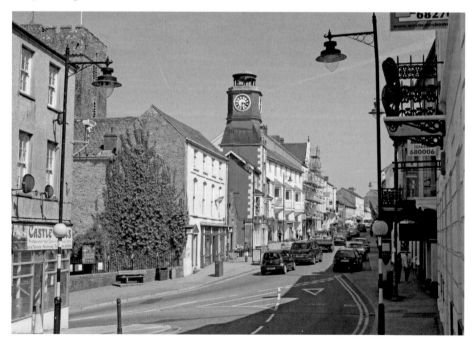

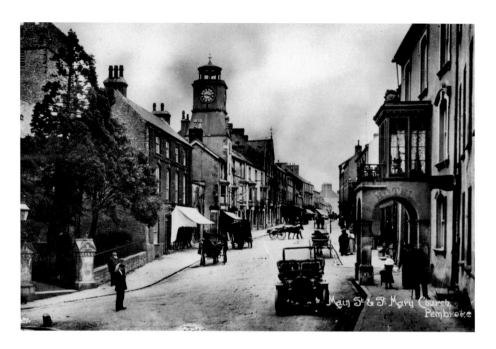

Early Tinted Image

This view with the Golden Lion Hotel on one side, and Brick House and Clock House with its clock tower on the other, must have been photographed many thousands of times over the years. In most of the early postcards, men and boys can be seen leaning against the railings of St Mary's church to the left. Brick House was a confectionary shop run by Miss Hopla, then taken over as a tobacconist run by Mr W. Gullam – known affectionately as Billy Two Sticks. The Clock House then became home to a very early WHSmith newsagent, with a barber's shop above run by barber Clip Thomas.

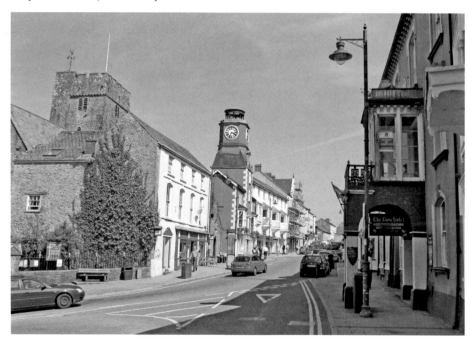

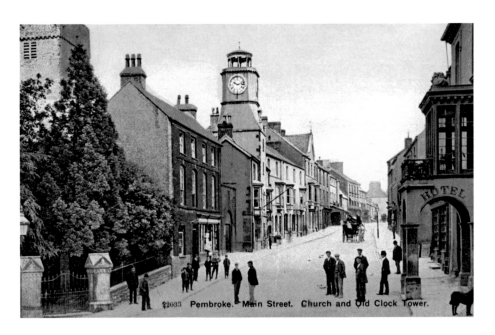

22033 Pembroke. Main Street. Church and Old Clock Tower.

Site of the Old Shambles and Market

The original clock and tower were erected after 1820 when the old Town Hall, which stood where Clock House is today, was moved over the road to its present location. The 'Shambles' – butchers stalls and a slaughter house – were also moved. The tower ensured that the clock could be seen from as far away as possible – watches were undreamt of at that time. By 1890 a new, higher tower had been built, which helps to date postcards from around that time. In 1897 the ground-floor premises that would become WHSmith was occupied by Elizabeth Matthews, who ran a bakery, and her Welsh cakes and rice pudding were in great demand. With her white cap and flannel skirts, she was a well-known character and was known as 'Bessie the Clock'.

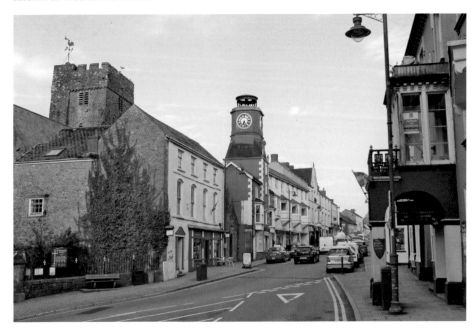

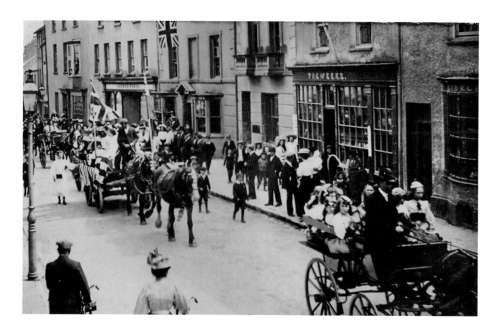

Treweeks – a Georgian Business

This busy summer parade scene is passing shops that have changed little in over 150 years. Treweeks, established 170 years ago when King George was on the throne, is still a chemist today. It was bought by John Mendus, who carried on the pharmacy, and in those days it still retained all the hardwood shelves and the small drawers for dispensing, along with a wonderful array of pots and jars. The building next door still has its stone balcony, and the premises beyond belonged to Robert George, who used his offices for the wine and spirits business. London House, with its five first-floor windows, was known as Pratts Emporium – a superior store of distinction, and it later became the Co-operative Society.

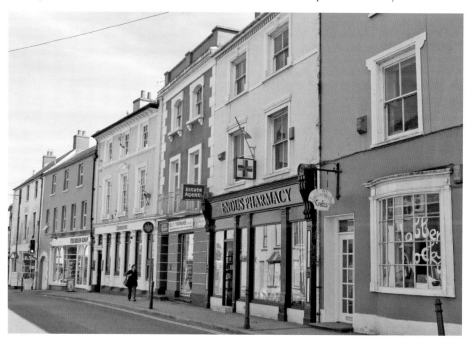

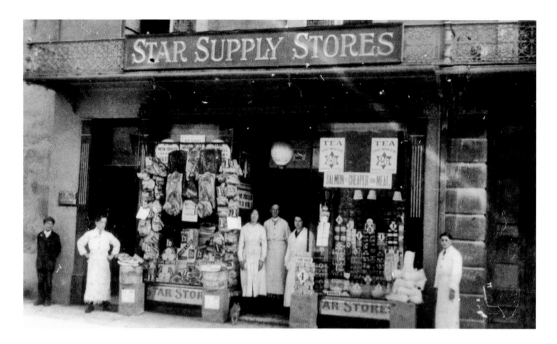

Star Supply Store

With a Star Supply Store in Pembroke Dock and other Pembrokeshire towns, Pembroke's store (seen above) was one of the very first chain stores in the area. The International was another one, though Home & Colonial didn't get this far. Selling everything from Pears soap to Dolly Blues, purchases would be delivered by bicycle, and the manager was Mr Jack Thomas. To one side of the Star Supply was Cash & Co., a boot shop, and on the other side was Waterloo House, where F. Tombs ran a ladies' and gent's outfitters.

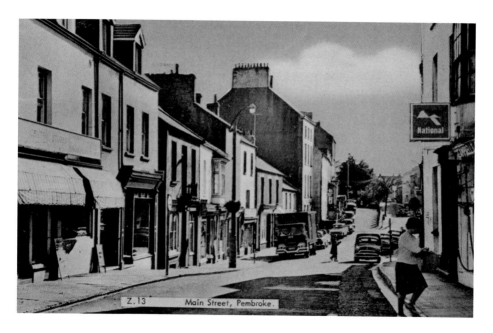

Z.13 Main Street, Pembroke.

Morgans Way and Melias Store

One of Pembroke's busy and popular garages, run by Ronnie Campbell, was situated to the right of this photograph. The petrol sign can be clearly seen showing exactly where the petrol pump was. Cars just pulled up at the side of the street to fill up. On the left side was a cycle shop, cabinetmaker and furniture/furnishings shop, the Liberal Club with a billiard table, and Roderick the plumber was in the same building. Sidney Brown's first fish and chip shop was at No. 44 on this side of the road. Melias was a greengrocer's shop with Nully Owen as the manager. In a forward-thinking move, the local authority demolished the building and created a pleasant walk down to the Millpond, naming it Morgans Way. Much later, however, they reversed the situation and filled the gap in again, with flats above and a passageway through instead.

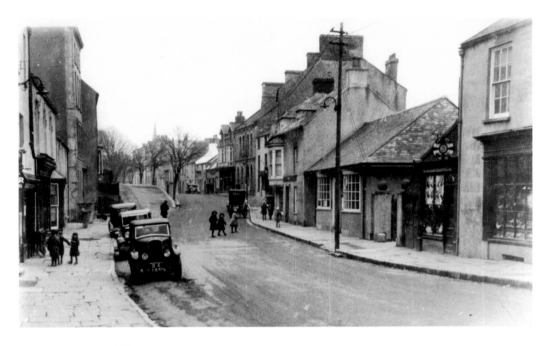

The Modern Post Office

The 'new' post office building looks quite modern, but was in fact built in the 1930s. The land had been acquired in 1915 when the existing post office was situated nearer the castle, and the semi-derelict properties on this site were deteriorating badly. To the rear was Pembroke's Telephone Exchange, with its tall telegraph pole, which was built on three levels going down to the Commons. The quaint little shop between the post office and Gwyther's tailor's shop was Backhouse Music Shop. They had another shop in nearby Pembroke Dock and advertised themselves as 'Pianoforte and Gramophone Dealers'. They also sold His Master's Voice and Columbia records, to be played on a turntable.

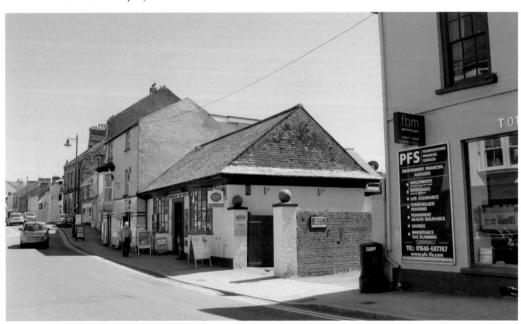

Austin Sayse Lewis

A keen photographer, Austin Sayse Lewis built new premises for his store around 1895. He kept a diary for some years and one entry reads 'Heard the Nightingale'. Hal Lewis and wife Pat then took over his father's business,, which had been known as 'The Mega Store'. Their main customers were farmers from outlying farms and here they could purchase everything from long johns to thick woollen socks. To the rear of the shop was an Aladdin's cave of kitchen provisions, everyday pots, pans and china, along with better quality china for your 'best'. When Austin and Pat remodelled the shop, they sold gifts to the front and stationary and toys to the rear. Many Pembroke people remember with fondness spending their weekly pocket money there, and mothers would have a special or expensive toy 'put by' for Christmas, paying something off weekly until bought. The toys were then delivered after dark on Christmas Eve.

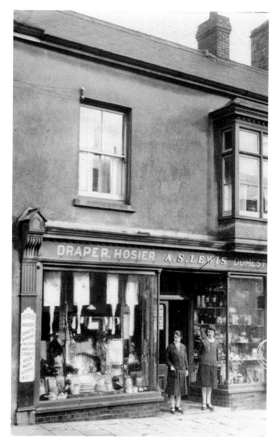

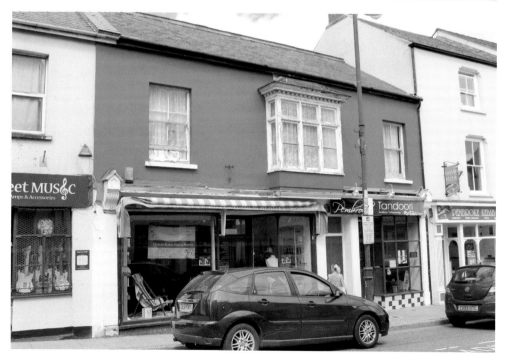

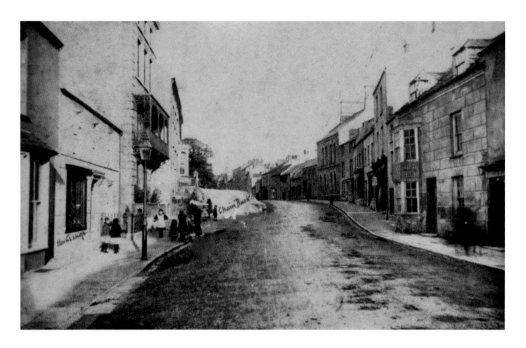

X Marks the Spot

The cross on this old photograph marks the spot of an accident, but what actually happened remains a mystery. To the left by the gas lamp was Frank Stern's Cambridge Studios. His son and grandson went on to run the cattle mart in East End, and then opened the estate agent W. E. Thomas. Beyond is Shaftesbury House, for nearly 100 years the premises of Lowless & Lowless, Solicitors. On the other side of the road, where Brown's fish and chip shop is today, was the Bush Inn, which had a variety of landlords and landladies throughout the 1800s, finally closing in 1892.

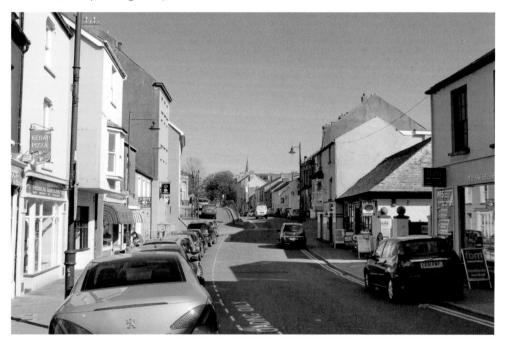

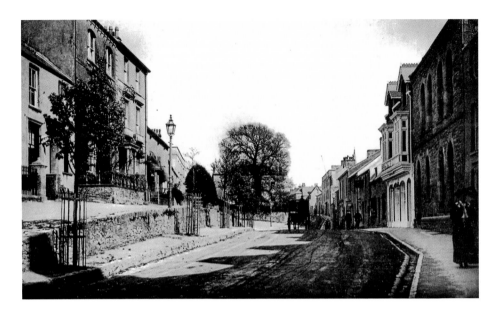

Medieval Area for Fairs and Markets

Beyond the Chain Back in Main Street is a junction where the road divides, only to join up again a few hundred metres further on. The house numbers of North Main Street cease at the beginning of this split, and then recommence where the road meets up again at St Michael's Square by the church. This area would have been where fairs and markets were held back in medieval times, and other examples of this widening of the road can be seen in the few towns that retain their burgage-plot layout. The north arm of the road is known as East Back, and was once the service area of town with its police station, police house, registry office, and cottage hospital. Further along was Birchell's Coach Works, established in the 1850s as a wheelwright's and becoming fine carriage builders thirty years later. The building has altered little in the intervening years.

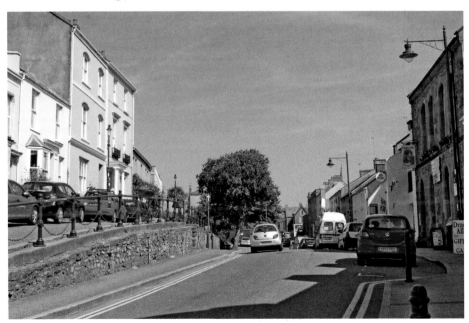

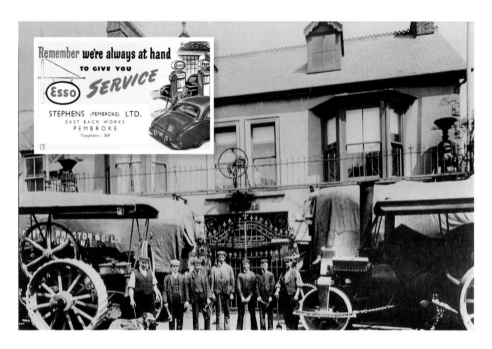

Stevens Engineering Works

Next door to Burchill's was Stevens Engineering Works, which became an important employer in the town. Not only were engines and machinery built and repaired, their steam engines were hauled from farm to farm by horses to drive threshing machines. Huge engineering projects were carried out; steamrollers and tractors had to be housed down on Well Hill. Later, when the earliest motorcars began to appear, the firm embraced the new era of petrol engines. The business had been opened in 1880 by blacksmiths John and Archibald Stevens from Castlemartin. It was Archibald's young son whose fist is the model for the handles on the wrought-iron gates to the workshop at the rear of the building.

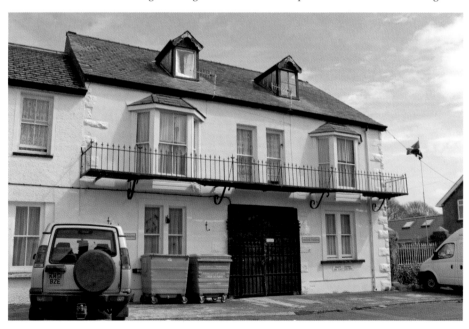

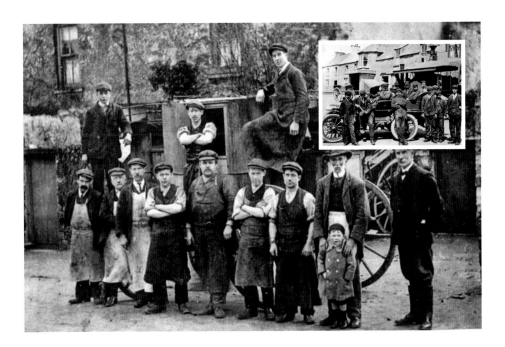

Hats and Leather Aprons

Seen here are the staff and apprentices from Burchill's coach works. Hats were worn by everyone in those days, including workers and boys. Apprenticeships were the usual way young people trained for a lifelong job in those days; the school leaving age was fourteen unless parents had money to support their children going on to higher education. Like Birchell's, Stevens Engineering also employed many apprentices. They were clearly respectful of their employers, and when Archibald's daughter married in 1911, the apprentices collected enough money to present the couple with a silver-plate tea service.

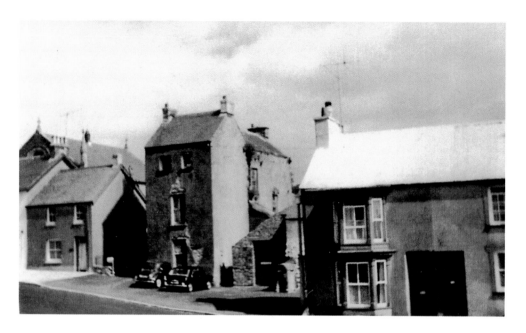

Was This a Medieval House?

Little seems to be known about the origins of this tall building with its central door on the first floor. Located towards the end of East Back, it has a large extension at the rear, but this may have been an addition rather than part of the original building. Its narrow frontage and three stories indicate that it may well have been a medieval townhouse; in general plots were approximately 14 feet in width, though there are parts of Pembroke where they are much wider or even double that measurement. Houses on East Back were only built along the north side of the road, and had burgage plot walled gardens running right down to the old town walls by the Millpond.

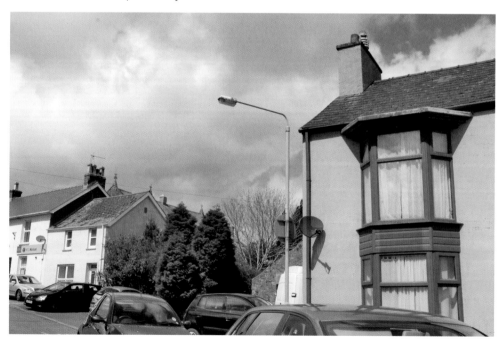

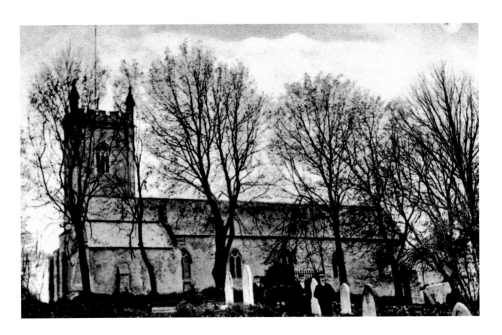

St Michael's Church

The unusual view above is taken from the back of St Michael's church, but it is impossible to match the scene with a modern photograph due to the extent of tree growth. The identity of the man in the foreground is unknown. The church has medieval origins, with a square tower, and is located in the east end of town, there being two parishes and two parish churches within half a mile of each other. The other church is St Mary's at the west end of town. John Poyer is associated with this site, and John Wesley is known to have preached to crowds in the square outside at a preaching cross that had been erected there. Having fallen into disrepair, the church was fully restored in 1835, and was further rebuilt in 1887 when the steeple was added. Regrettably the church had to close in 2012.

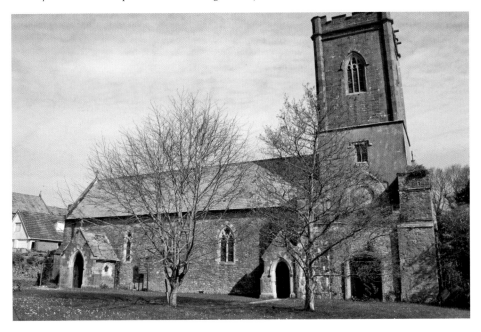

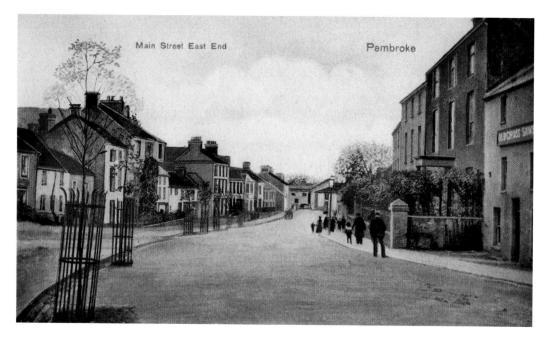

Main Street East End Pembroke

Grand Houses in the Middle of Town

Looking to the east from St Michael's Square, the scene today is full of traffic and road signs, and some of the houses have gone, though the scene in general remains the same. To the left of the photograph, six cottages that were in front of the church were removed to form much-needed Main Street parking and to allow a view of the church from Main Street. Further along on the left, the old and 'colourful' Black Horse pub was also demolished – this time to create an attractive way down to the Millpond and Barnards Tower. The road is wide and graceful, with the planting of new trees adding to its attractiveness. Most of these trees have now matured and some have died, but an extensive enhancement scheme now taking place will include two new trees.

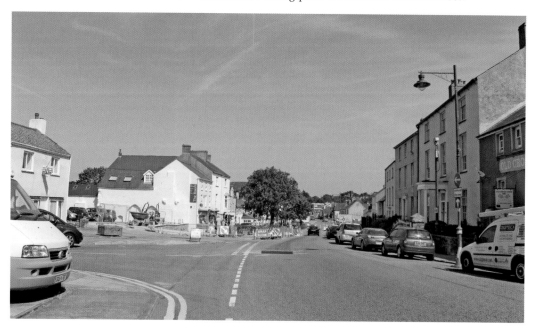

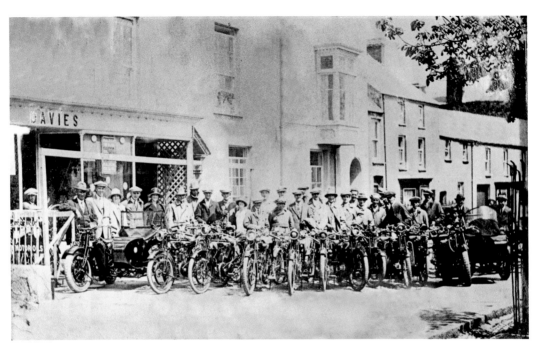

Motorcycles and Accumulators

Today the shop is called The Room, and 100 years ago it had just had a facelift after a new shopfront had been designed. Davies Cycles were popular for their Raleigh bicycles and all accessories needed for the new and exciting fashion of bicycling. Annual motorcycle rallies set out from here too – no crash helmets in those days, though everyone in the photograph is wearing a hat of one sort or another! To the rear of the shop was a room where glass accumulators were recharged in the early years of wireless sets. Several ladies from the Colley family remember girls carrying the batteries by hand to be recharged every week. Each family would have two batteries so that one would be left, and the fully charged one was carried home complete with battery acid. There was no thought of health and safety in those times.

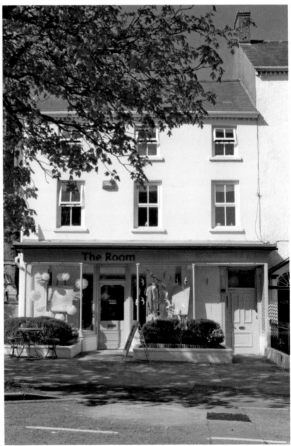

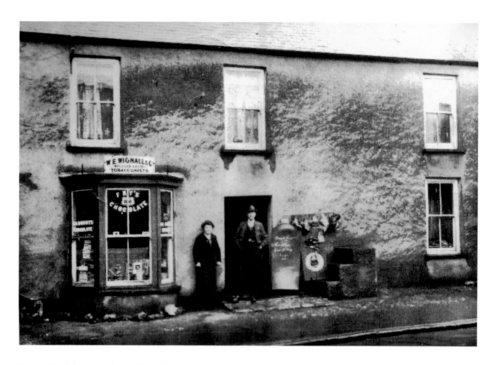

From Red Lion Pub to Lion Store

Once it was the Red Lion pub, then when it reopened as a general store it was known as the Lion Store. Today it is known as Top of Town fish and chip shop. The building is clearly old – the stone steps were for climbing up into, or loading goods into, carriages. Seen in the photograph are little Lizzie Wignall and tall Willie Devote. Their families also ran the nearby Blackhorse pub, the Eastgate Hotel, the Coronation Stores, a shop on Froyns Terrace, and a game merchant's business. The Devotes came to Wales from Italy in the early 1800s and set up a Marine Chandlery store, so they may have been sailors. There are several established Pembroke families with forebears from the Continent – Asparassa from Sicily, Brickle from Germany, and Campodonics from Genoa.

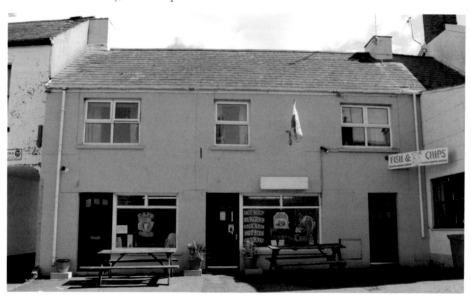

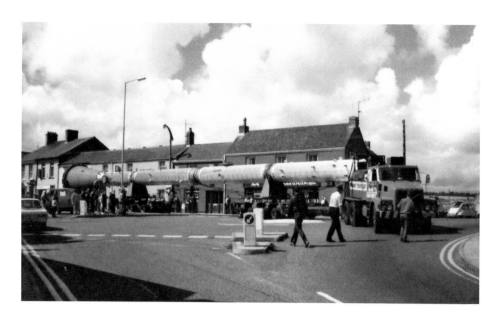

East End Square, Site of the Old Town Wall's East Gate

The relatively small area known as East End Square must have been ridden or driven over by the heroes (or villains) in centuries of stories: from Rhys ap Tewdwr, the last Welsh king, who would undoubtedly have come to this area, to Lady Margaret Beaufort travelling past here on her way from Lamphey Palace to Pembroke Castle when pregnant with Henry Tudor. Cromwell would have passed through the great East Gate too, and Daniel Defoe and painters Sandby, Norris and Turner when travelling from Pembroke to Tenby. In the last century, English tanks trundled their way from the railway station to Castlemartin Range, and for decades German tanks were brought in on huge low-loaders. Then there were the long loads, the high loads and the extremely wide loads of the massive machinery and plant equipment bought in for the construction of the oil refinery and power station some miles away – all having to travel through the end of Main Street – and yes, quite a few got stuck!

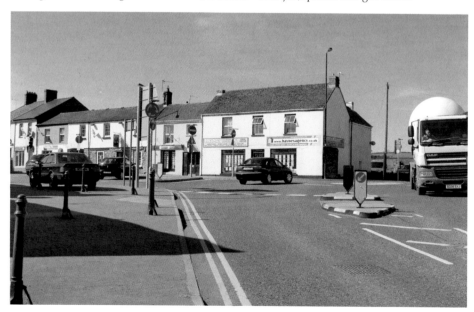

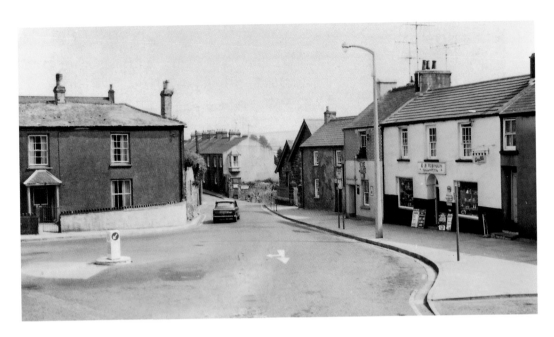

In Quieter Times, Before Street Signs Began to Multiply

In times gone by, the East End was the working end of town, with a strong sense of community that still exists today, and it was bustling with life on all levels. Within a very small area were many pubs, including the Hope Inn, the Royal Oak, the Railway Inn and the East Gate Hotel, the Blackhorse, the Commercial, the Maltsters, the White Lion, the Red Lion, and the Rifle Corps Arms. All but the first two are now closed – gone but most definitely not forgotten. East End House has also been demolished, with the aim of preventing large accidents and very large loads (often tanks on low loaders) getting stuck at the top of Well Hill. The house was interesting in that it had one of the bedrooms extending into No. 7 Station Road next door to it.

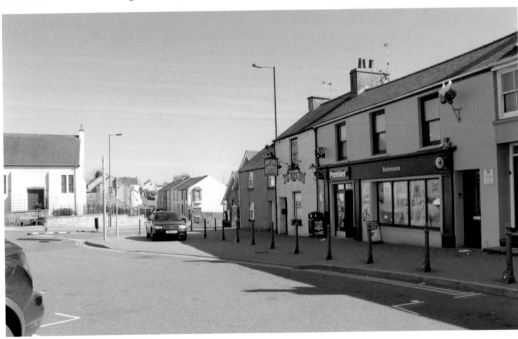

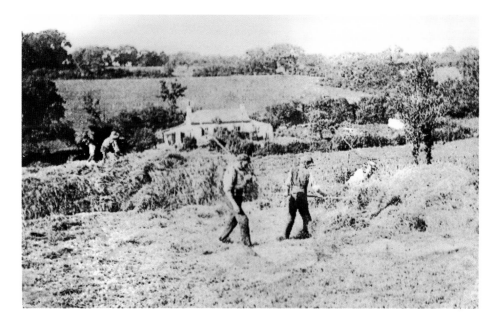

Lords Meadow

Lords Meadows Farm was acquired by Mr and Mrs A. J. Roblin in 1906, and was next farmed by their son George Roblin, whose dairy herd provided daily delivered fresh milk to the eastern end of Pembroke. It is now in the possession of their grandson, John Woodward – over 107 years in the same family! John's sister Carol also still lives nearby and remembers haymaking being hard but happy work. Her uncle, George Roblin (born 1904), knew a great deal about plants, trees and birdlife, and her son Jack still remembers what his uncle taught him and the names of all the cows, even though there has not been a cow on the farm since 1984. One boyhood memory George used to recall was looking up from Lords Meadows to Holyland Hill and seeing a circus coming to town, complete with elephants walking down the hill in a line trunk to tail.

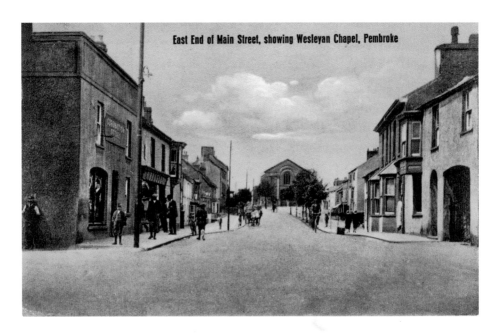

East End of Main Street, showing Wesleyan Chapel, Pembroke

The East End of Town

The great East Gate into the walled town stood here. It was similar to Tenby's five arches with a portcullis, and from there the town walls ran left parallel to Gooses Lane, and on the right followed the line of the kennel timber down to Barnard's Tower. The Coronation Stores shown in the photograph was run by Mrs Devote, and was formerly the Maltsters Arms. Next door is Beasley's, which had formerly been the White Lion, and is opposite Brighton Mews – its coach arch is still visible today. The nearby cattle mart, busy railway station, timber yard and other local businesses ensured that the many pubs here were always busy, with hard work and long hours being rewarded at the end of the day.

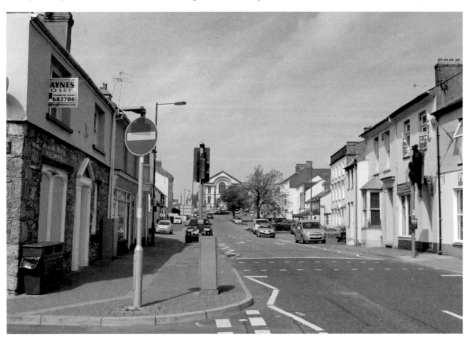

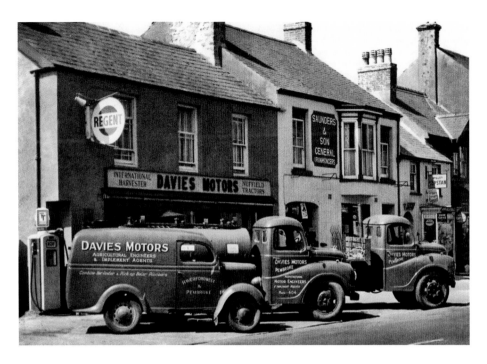

A New Fleet of Vehicles

These fine vehicles were owned by Davies Motors. Govan Davies and his wife, Daphne, moved here when they were first married, and as the business expanded an access was created to the rear of the building to create a yard, stores, and repair shop. Later, petrol pumps were installed and eventually the garage became a Texaco filling station. Charlie Saunders owned the ironmongery store next door, and the little sweet and cigarette shop was run by Wally and Joan Jones. They sold many other things such as Dinky cars, and Mrs Jones ran a lending library that was very popular with the local ladies.

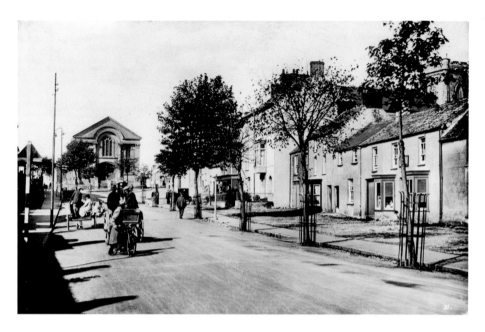

An Imposing Italianate Chapel

The first Wesleyan meeting house was built here in 1822. John Wesley made dozens of trips to Wales and would have preached at the preaching cross, where large crowds congregated to hear him. He also preached on the hill opposite at the church of St Daniel. Wesley kept diaries and wrote that 'it always rains in Pembrokeshire'; however, it did not appear to deter him from his visits. In 1878, at the time of the great chapel-building rivalry in Pembroke, the new, imposing Methodist chapel was built. There was room for a large and very popular Sunday school on the lower floor. Back in the thirteenth century, the site where the chapel stood would have been an open area kept for regular markets and fares.

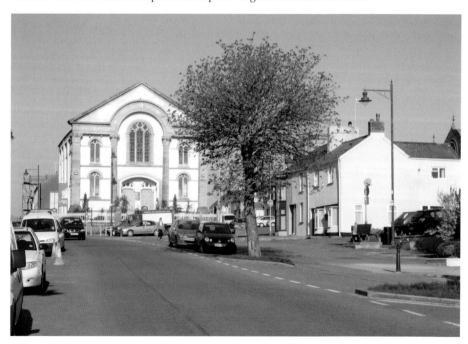

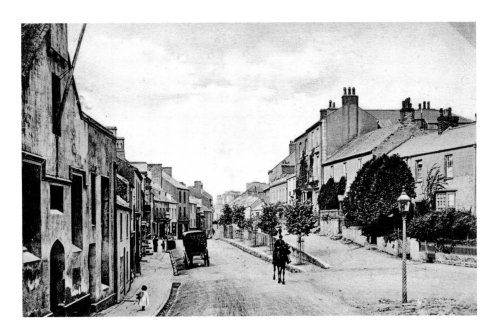

The Little Girl

The wall on the right is the end of the garden wall of Hamilton House, where Emma Hamilton stayed when she toured South Wales with Lord Nelson. The little girl in the bottom left of this picture is gazing up at one of the Victorian National School's windows, though quite why remains unclear. The school, opened in 1861, later became a church hall to St Mary's and is an antique centre today. Of special note is the superb wrought-iron post of the gas lamp – gas had been installed in the main street in the 1850s, and for a while there was a gasometer on Pembroke Commons.

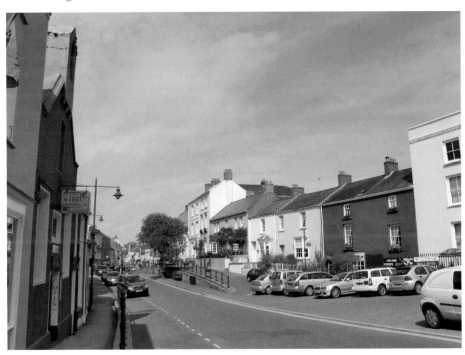

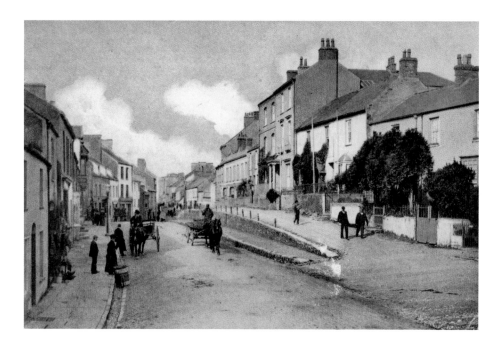

Looking West

This fine tinted Victorian 1904 postcard has several things to note. There are no trees at all on Chain Back, and in fact no 'chain' either. No. 74, the nearer of the three-storey houses, was the grand townhouse for the Owens of Orielton estate 3 miles away. Author Keith Johnson wrote that in the early 1920s, a hole had opened up in the road in this vicinity. With the help of ropes and ladders, men unsuccesffully attempted to reach the bottom. The hole was quickly filled in again – a steamroller had been in danger of falling in. Pembroke is built on limestone and it may have been a cave. It could also have been one of several tunnels that appear to have run from north to south in times gone by.

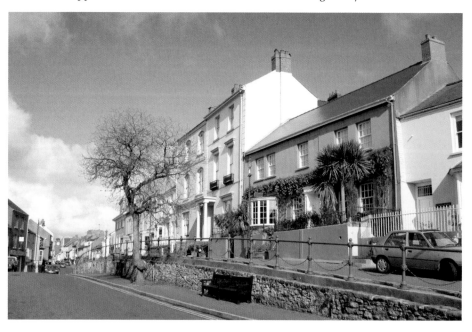

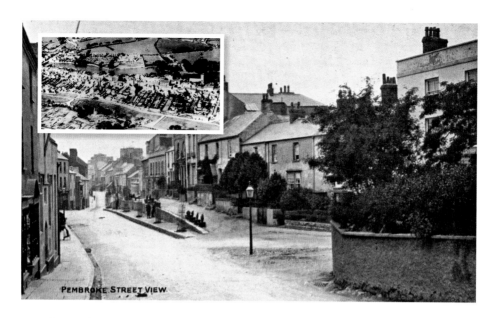

PEMBROKE STREET VIEW.

Grand Georgian Houses on Chain Back

At the far end of Chain Back, the small terrace of three similar houses is called Orielton Terrace, built to house soldiers and their families. The Baptist manse is next, and the two three-storey houses in the centre were occupied by Jack Ford from the mill and Norman Lowless, solicitor. Both these houses are exceptionally fine examples of Georgian buildings. Like other Main Street houses, they have a narrow frontage but stretch a long way back, sometimes with servants' quarters. The gardens, or burgage plots, stretch right down to the town wall by the Millpond, and for centuries would have been important. Plots of the upper-class houses would have had ornamental planting with glass houses for fig trees, apricots and Mulberry Bushes – being on the north side, there was far less sun. On the sunny south side, and especially where working people lived, gardens would have had extensive vegetable plots, with apple, plum and pear trees, as well as raspberry and gooseberry bushes. Most houses would have kept chickens and even pigs.

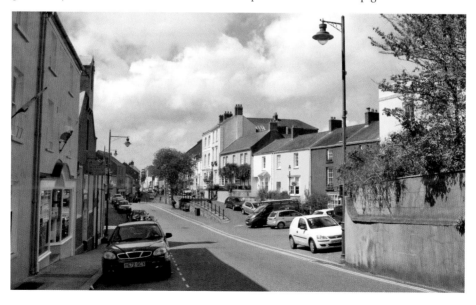

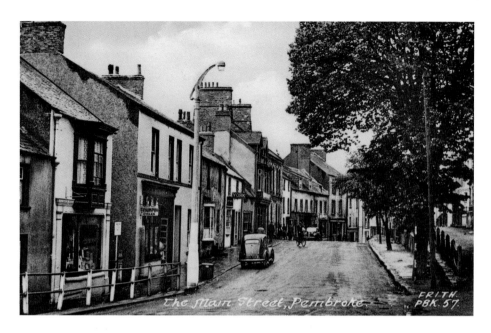

The Main Street, Pembroke. FRITH. PBK. 57.

The New Way

Filthy, dark, and dangerous is how the steep lane leading down to the Commons was described before it was improved in 1861, thus giving it the name New Way. Tucked in between the two houses on the left of the picture, the New Way is near the boundary between the two parishes of St Mary's and St Michael's. The dip in the road at the top of New Way is further indication that this may mark the limit of the earlier town settlement – there would have been a ditch and walls here. The little sweet shop on the corner of New Way was run by Mrs Foggwell, and later her daughter Vicky. The York Tavern, sadly closed, is said to have been the oldest pub in town, and where Cromwell made his base. Further along, the Trustee Savings Bank, now Dragon Alley, began life as the Penny Savings Bank.

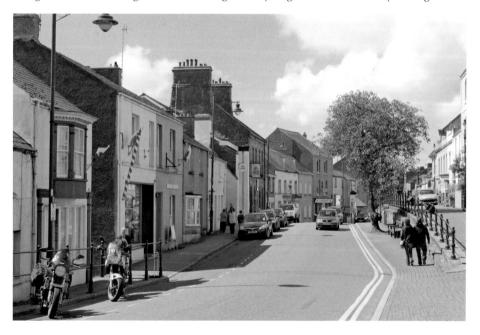

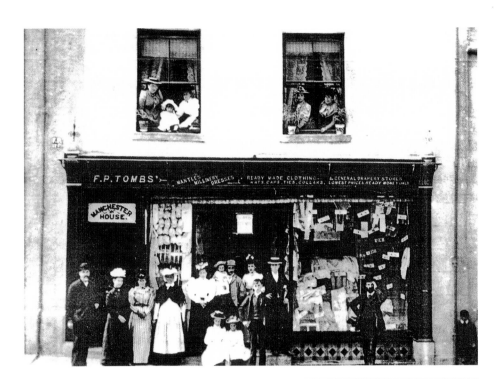

Tombs Emporium

Staff and family stand outside No. 55 Main Street – the premises of F. P. Tombs. The house was known as Manchester House, and is one of many that have names reflecting towns in Britain; other examples are London House, Exeter House, Edinburgh House, Richmond House and Brighton House. The shop was a general draper's stores, and the sign tells us that they sold mantles, millinery, dresses, hats, caps, ties, collars, and ready-made curtains – all at the lowest prices ready money could buy. The building is thought to have been John Poyer's town house before he was executed for his part in opposing Cromwell in the Civil War. In 1930, it became the barber's shop of Leo Williams, and after that Davies clothes shop.

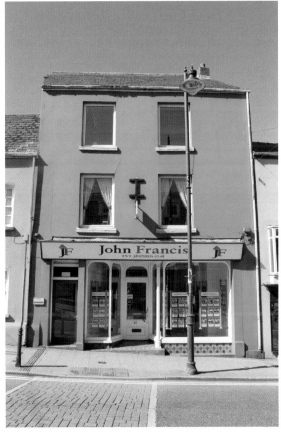

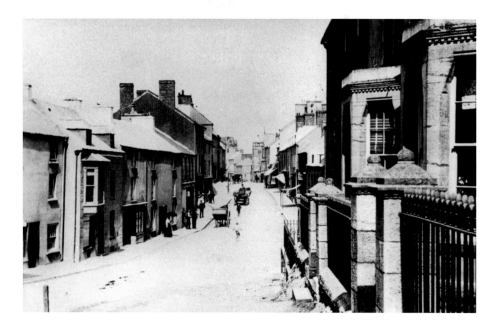

Looking Towards the New Post Office

The three-storey buildings that became the site for today's post office can be clearly seen here as a shop and two single-fronted houses. The photograph would have been taken in the 1880s, because the clock tower in the distance is still the old 'straight up' tower with its lovely domed top. The end of the Chain Back seen on the left doesn't appear to have pavement below it, and it has been suggested that the centre of the rise (outside the two three-storey Georgian houses) was where ladies would have been able to step straight from the edge into their carriages and so avoid the wet, dirty, or fouled road to maintain their elegance at all times.

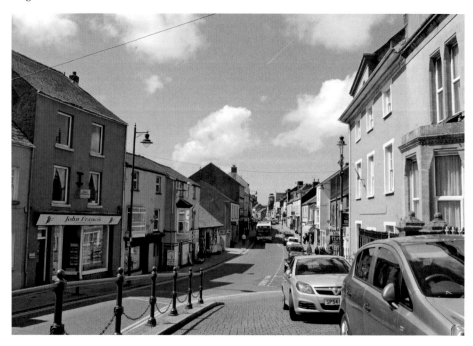

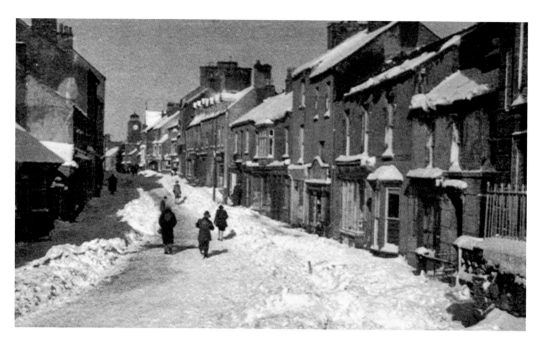

The Winter of 1947

This lovely photograph by Hal Lewis was taken in the big snow of 1947. Remarkably the trains were kept running, but cars and buses ground to a halt. Lanes were impassable, with villages and hamlets cut off, as were isolated houses. Although food was in short supply and heating became difficult, it was the toll on livestock that was the greatest. Snow drifts were over head height in some places.

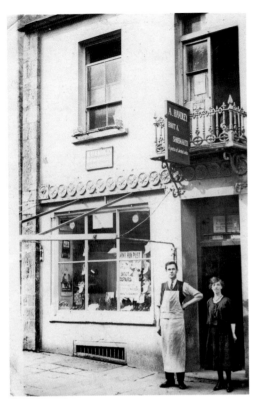

A Beautiful Balcony

Handley's Boot and Shoe shop, and their cobbler's repair service, is remembered as always being situated on the south side of Main Street. This delightful photograph, however, shows the shop at a location on the other side of the street in the early 1920s. It appears that there was a serious fire at Handley's premises at No. 63 (where K & K Insurance is today) and Mr Handley and family will have relocated over the road until their house was rebuilt – with only two stories instead of the original three. The fire did not extend to AGO. Mathias' Penny Savings Bank was next door – now Dragon Alley. The handsome balcony seen in this photograph is no longer there, but the unusual decoration of circles remains, and they (and the grill at street level) help to identify the building as No. 42.

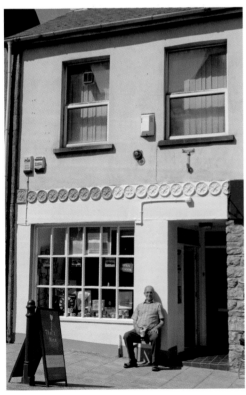

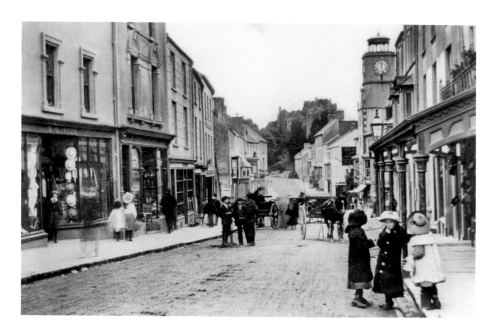

Hats – the Height of Fashion

This delightful turn-of-the-century postcard shows us that Pembroke may be as far west as a Welsh town can be, but it certainly wasn't behind the times fashion-wise. At the end of Queen Victoria's reign, hats were the height of fashion and no one was to be seen without one. This included girls of all ages, and the fancier the better! Everyday clothes – dresses, coats and skirts and blouses – would have been made from calico, cotton, gabardine, and moleskin for 'waterproof' wear. Despite her fashionable outfit and the fancy hat, the little girl on the left of the three girls is wearing heavy boots rather than fine leather. In the distance, the castle is still in ruins and ivy-covered, hiding the massive crack in the Gatehouse Tower resulting from Cromwell's destruction. There is also just a glimpse of the steps outside the Town Hall that went from Main Street up to the floor above.

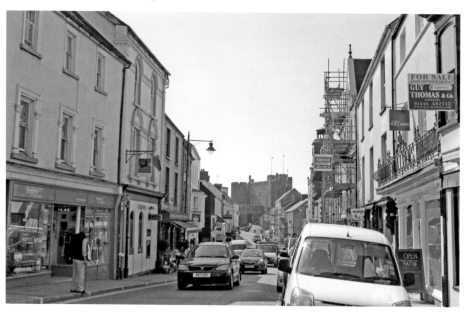

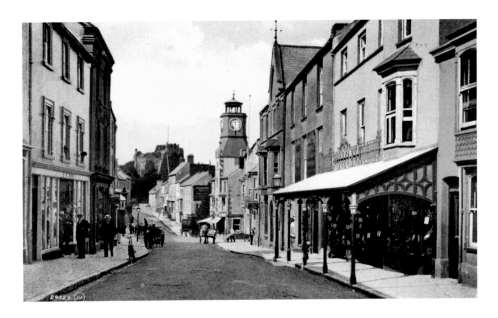

Shoes and Cinema Memories

Rees Shoe Company reflected the importance their extensive business by adding an elegant Victorian wrought-iron portico to their Pembroke shop, but unfortunately it was damaged when a vehicle hit it one night. There are few examples left today, but at the time they were the height of fashionable shopping and made a statement about quality and class. A few doors further along is the building that was once the Grand Assembly Rooms in the 1800s. By 1920, Rees Phillips had opened a simple cinema there showing early silent films, and shortly afterwards William Haggar took over the premises and established what became one of the most important venues in Pembroke – Haggar's Cinema. With weekly dances held upstairs to bands such as 'Charlie Bumstead', children's Saturday-morning matinees, the excitement of Ealing Studio thrillers and the latest Hollywood films downstairs, everyone was catered for. Today the cinema has become Paddles Nightclub, but the days of that cinema magic are remembered by all who were there.

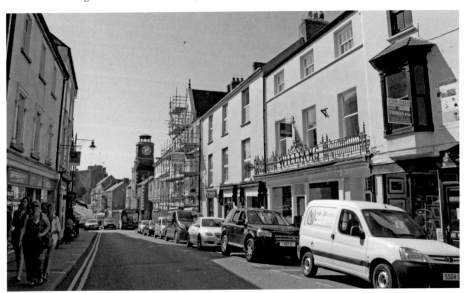

Beddoe and Beddoe

Two brothers, James and Arthur Beddoe, ran one of several ironmongers' businesses in Main Street – there was another one just two doors along, John Richards at No. 15. There was also Charlie Saunders and David Jones in the East End, and Elsdons in later years. The store was in two separate buildings that were side-by-side. One sold silverwear and household goods, and this would have been run by Arthur Beddoe, who was the general manager and an outgoing, military type of man with a moustache. James Beddoe was a larger but quieter man, who was sombre and 'front of house'. His side sold all the general and outdoor ironmongery. At the rear of the building there was an oil engine to generate electricity. It had a big flywheel, which had to be spun by hand to get it going. James and Arthur were great characters and had a very prim and proper housekeeper, Lizzie, who made wonderful cakes and fudge!

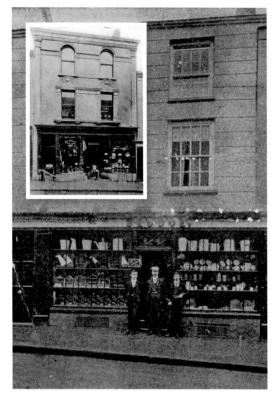

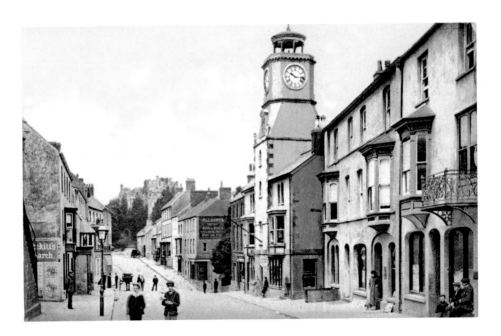

If Only

Simon's Store, run by Walter Simon from Thrustle Mill, was an 'agricultural food merchants', and sold corn and animal feed. They were also 'Purveyors of Groceries'. In this superb postcard there are many points to note. There are lovely arches over the doors, and fine windows. There is a horse trough outside the far end of Simon's, who also had their own delivery van, and the building on the right (Lloyds Bank) has yet another wrought-iron balcony on the first floor. Further on, the large advert on the building at the top of Dark Lane says 'Allsops', who would have been the predecessors of Pannels. Today there is still a small supermarket where Simon's store was, though sadly the elegant façade was demolished many years ago. On the left, the Town Hall has an attraction well worth a visit. The walls inside are covered with vibrant, colourful pictures, telling the story of the history of Pembroke from earliest times. They were painted over several years by George Lewis and his wife Jeanne.

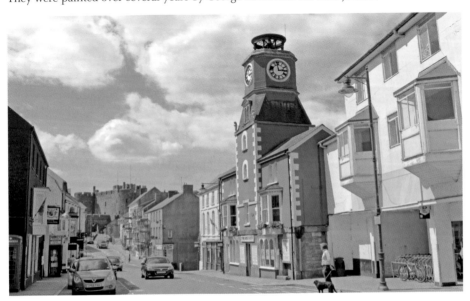

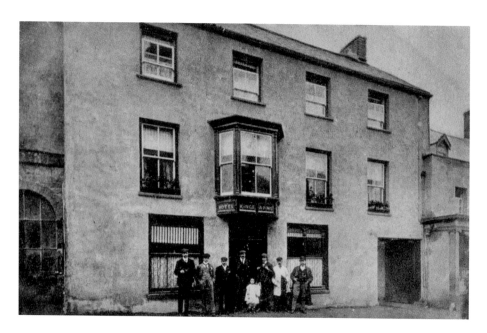

The Old Kings Arms

The Kings Arms is an old coaching inn dating back as far as the early 1600s. It was called The Bunch of Grapes for a while, and it is unfortunate that for a long while it stood opposite the town market and Shambles – basically a slaughterhouse – that was eventually moved to the Commons, where the sights and smell would have caused less offence. The Old Kings Arms is still a popular place to enjoy a drink or meal. George Wheeler, who bought the premises in 1957, is also remembered for his Rabbit Factory business, which indirectly employed dozens of people in the area.

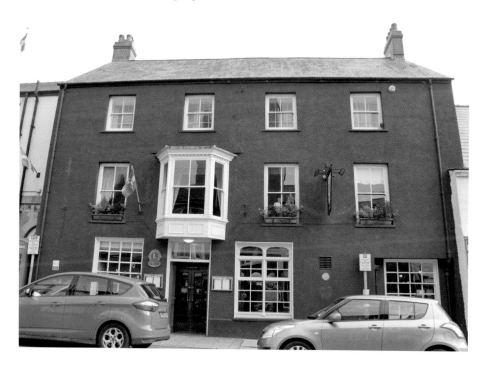

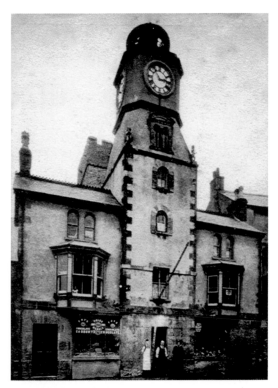

Clock House

Clock House with its central tower is a building that cannot always be fully appreciated because of the narrowness of Main Street at this point. Access to the clock above the fifth-floor window is given as a way to enable the clock to be accessed for repair and maintenance when needed. There is uncertainty around the exact date the tower was altered, but the fine postcard is dated 1890 and shows the old 'straight-up' tower, indicating that the construction was earlier in the 1880s. Originally, there were four cherubs up on the corners, but only two remain. Bessie the Clock can be seen in the photograph, but the identities of two gentlemen remains uncertain.

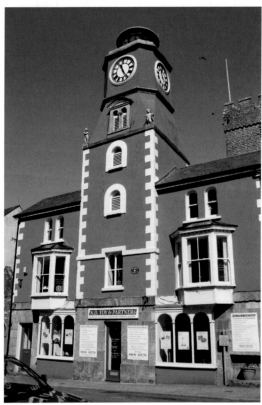

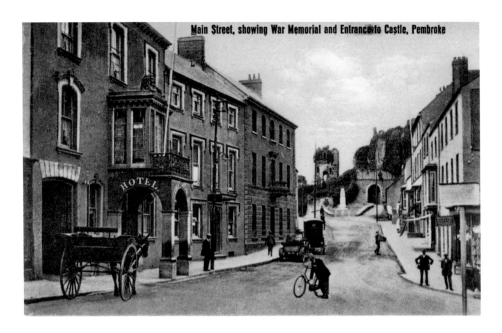

The Golden Lion Hotel

Situated at the top of the Dark Lane that leads down to Mill Bridge, the Golden Lion was one of Pembroke's best coaching inns. Around 150 years ago it was in competition with the Green Dragon as to which was the smartest establishment in town (the Dragon was situated where NatWest Bank is today). The Golden Lion, known more recently as The Lion Hotel, was owned by the Owen family, who used it as their base for their election campaigns. When the estate had to be sold in 1857 there were thirteen bedrooms, many public rooms – including a parlour and a farmer's room – and stabling for twenty-one horses. Later, there was a motor 'taxi' service from the hotel to Pembroke railway station. The hotel has recently closed, but the lion still looks down over his domain from outside what was once a small ballroom.

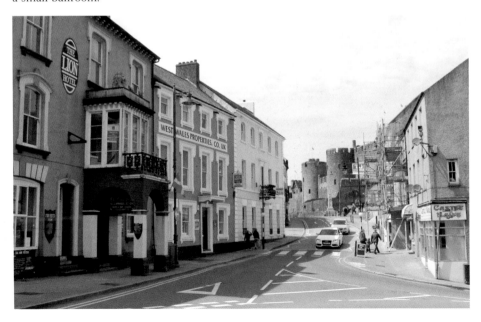

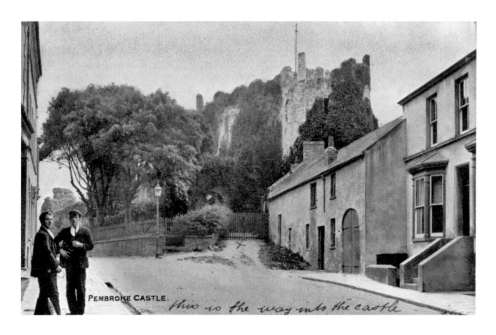

PEMBROKE CASTLE. *this is the way into the castle*

The Castle Entrance Ninety Years Ago

Taken around 1924, shortly before work began on the castle renovations, this attractive postcard shows the entrance to the castle. It shows the ruins of the Barbican Tower – blown apart with Cromwell's gunpowder – and stables and a coach house on the right-hand side. These stables were used by the gentry when they stayed in their town houses, mostly along Main Street. Before the First World War, a Territorial Army was formed and a Drill Hall built to the rear of the coach house, which was demolished for access. Also removed decades earlier was a tiny cluster of medieval cottages, sketched by Charles Norris in 1837, that stood where the war memorial is today. The memorial commemorates local men who died in the First World War and is a replica of the Cenotaph in London. It was built by monumental stonemasons Colley & Sons in 1924.

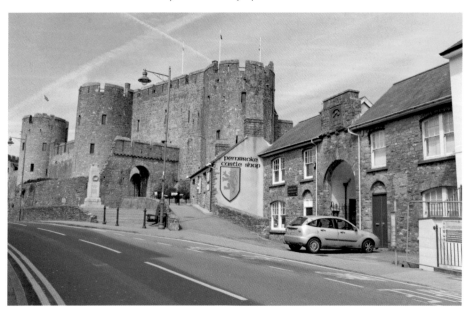

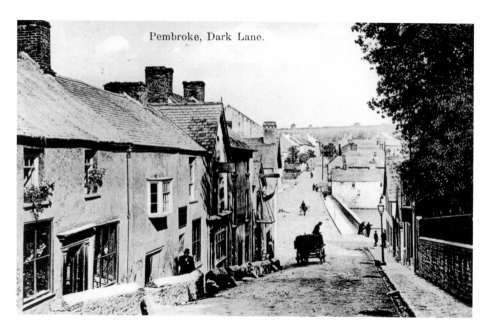

Pembroke, Dark Lane.

Steep, Dark and Dangerous

Standing at the top of the Dark Lane 100 years ago, you would have seen the West End Vaults, the Mariners Arms and the Globe Inn, with further pubs at the bottom – the Royal George, the Red, White and Blue, and the Waterman's Arms. Prior to 1814, all trade came into the area by ship. In 1814, however, a new dockyard was built on lands at Paterchurch and the town of Pembroke Dock quickly grew up around it. Horse-drawn traffic up and down the Dark Lane therefore increased dramatically and accidents were rife. The North Gate would have contributed to these problems and so was demolished, enabling attempts to lessen the gradient of the hill, as well as rebuilding the South Quay.

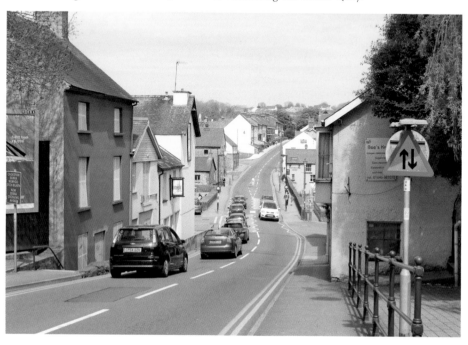

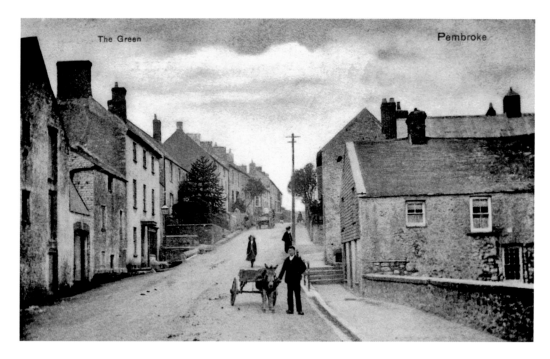

The Green Pembroke

The Waterman's Arms

This evocative photograph tells its own story. As so often happened in the early days of photography, the man with the donkey has paused as he looks at the photographer. Trading for over 200 years, the Waterman's is still a pleasant place to enjoy Millpond views and look for glimpses of otters. Up until the 1960s, however, it was not a place to have taken your family. A door in the once slate-clad front of the building led straight into a 'Men Only' bar, with sawdust on the floor and a good time had by all. Further up the road was Croft House, for many years a children's home and today a pleasing sheltered housing development.

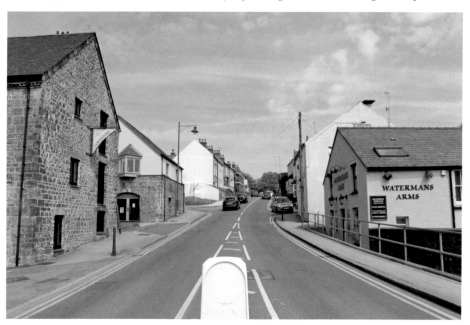

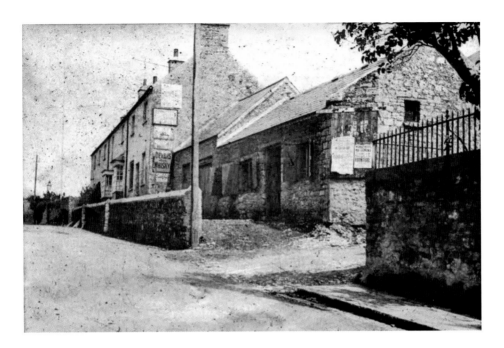

The Smithy on the Green

It is hard to imagine just how important blacksmiths were in times past. This one was situated a few doors up from the Waterman's Arms, just past a tiny church 'meeting house'. Beside the smithy was a blacksmith's shop and stores used by Pannell's the furniture remover's. We take water on tap for granted today, but 100 years ago it was often unclean, and had to be fetched. A scheme to supply water to sites all over the town resulted in the building of many collection points providing fresh water for the nearby properties on demand. Many still remain and can be seen around the town, either in dressed limestone recesses or with red-brick walls. Unfortunately, the supply near to the smithy disappeared around the time the cottages and smithy were removed for redevelopment.

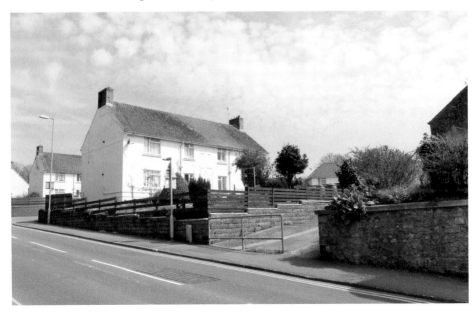

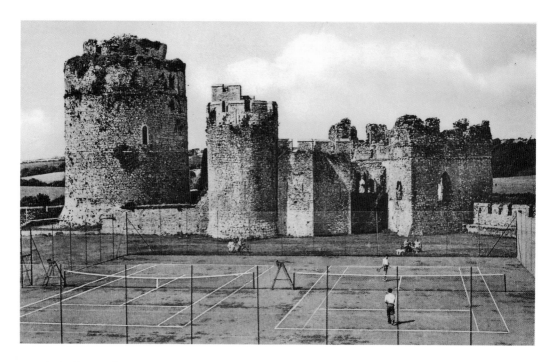

Tennis in the Castle

Until renovations on the old castle ruins were undertaken by Sir Ivor Phillips, the castle interior was kept trim in an unusual way. Sheep grazed the grass and kept it naturally short and weed-free, and the popularity of the widely played game of tennis took advantage of this. Tennis courts were marked out and seats installed for spectators, with the ladies playing in long skirts and men in flannel trousers. Young people from the business families in nearby Main Street would meet here and take part in weekly tennis matches. Many lifelong matches were made here too.

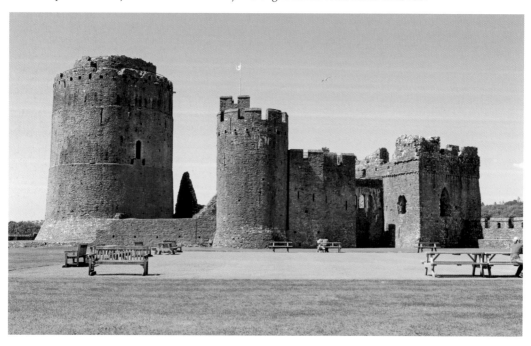

Reflections in the Window

No. 5 Westgate Hill is the subject of this delightful photograph that dates from 1905. The three Goodall sisters stand outside – the smallest, Doris (born 1898), became the mother of Pembrokeshire's well-known classic car enthusiast, David Mathias. Pembroke Castle, then an overgrown ruin, is reflected in the upper windows. The handsome iron railings, removed long ago, were perhaps surrendered to one or another of the war efforts. John Russell, the well-known auctioneer, grew up at No. 5 in the early twentieth century and the wall of 'babbyloobies' (ornamental stones) that replaced them was built by his father.

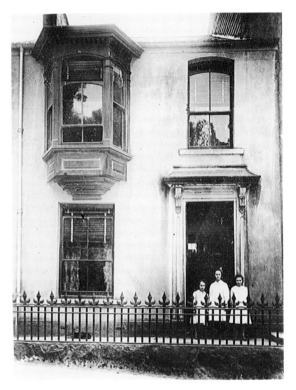

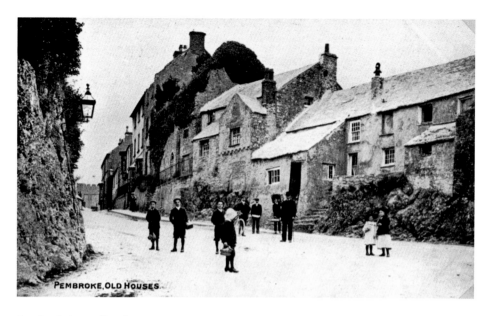

PEMBROKE, OLD HOUSES.

Pembroke's Medieval Cottages

A hundred years or more ago, the people in this scene would have felt they lived in rather modern times. Gas lamps lit the way at night, and the road had been widened many years before, with a pavement provided to improve matters when rain resulted in torrents of water pouring down the hill. The cottages are medieval and little changed, with undercrofts, the remains of a town lock-up, and sturdy chimneys. On the opposite side of the road and to the left-hand side in the photograph there stood another row of cottages. There were even more cottages built just above them under the town walls, including a pinfold for stray livestock, a stonemason's yard, and one of the earliest Methodist chapels – in 1843 they had a congregation of fourteen. The cottages were demolished around the late 1870s and the narrow mud road was widened for safety.

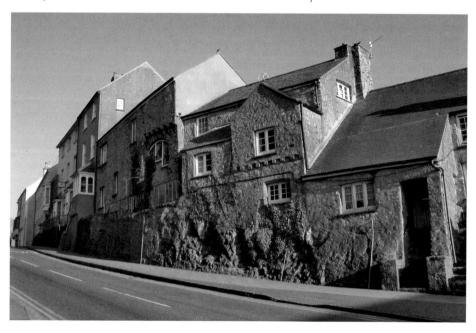

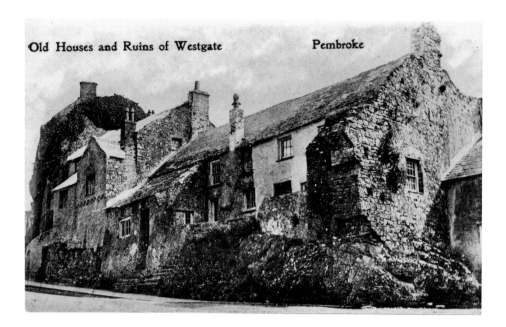

Old Houses and Ruins of Westgate Pembroke

Remains of the Old Norman West Gate

All that remains of the vast West Gate situated at the bottom of Westgate Hill is a small part of the springing arch, shown in the photograph above. The medieval gate guarded the entrance to town from Monkton and the quay below, and it is not known exactly when it was demolished. It was probably around the time of the modernising of the quays – especially the south quay around 1818. Attempts were later made to try and reduce the steep gradient of the hill. In the late 1920s and early 1930s, when extensive renovations of the castle walls and interior buildings were being undertaken, limestone had to be brought in from far and wide. Some of this came from quarries in Monkton and great weights were hauled up the Westgate Hill by horses. The slope was so steep that extra horses had to be used, and young boys living in nearby houses would vie to be allowed to ride the horses back down the slope.

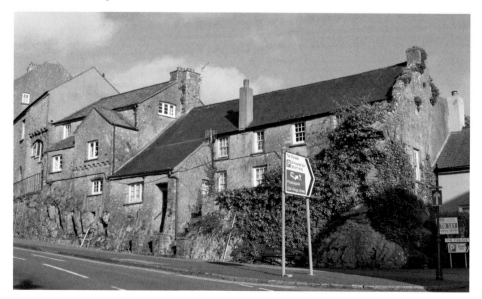

From Iron Foundry to Thriving Community Centre

The 1864 Ordnance Survey map of Pembroke shows an iron foundry situated on the Commons, which was run by George Lloyd and before him Thomas Morris – and also described as a 'brass founder'. A series of buildings surrounded the main building shown above, all encompassed within square and solid walls. Little is known about the foundry but it must have played an important part in the success of Stephens Engineering Works in East Back, and in the production of the handsome Victorian balconies and railings appearing all over town and beyond. By 1890, iron production had ceased and the Sherrin family had moved in. John Sherrin was a butcher and probably worked in the nearby slaughterhouse. In the 1940s, Foundry House was home to Robert and Georgina Seabourne and their children, then becoming the Police Boys Boxing Club. By 1967, it had become a busy Youth Centre run by youth leader Val McInally and continued by Roy Martin. Eventually it was put up for sale by the local authority. Pembroke Community Association managed to raise every penny of the asking price, and today it plays host to many community projects and over thirty user groups.

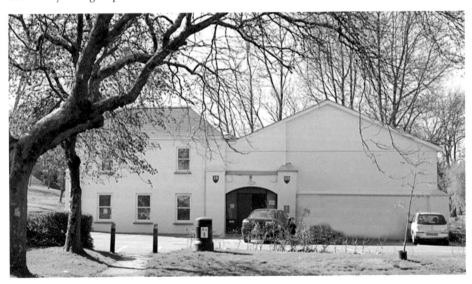

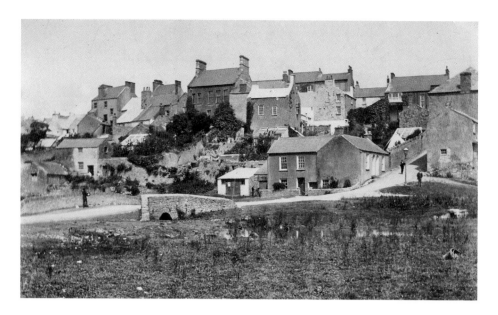

Little Has Changed on the Skyline

Pembroke Commons, running the entire length of the town's walls on the south side, has a complex history of its own and is much loved by residents and visitors alike. The image here shows the New Way, which leads steeply up to Main Street, and it is thought that this narrow part of the town's walls (narrow from north to south) may mark the boundary of the earliest Norman settlement before the town acquired Borough status and prospered, and had to be extended east. This meant that it was time for an explanation. Eventually, the town had over 220 burgage plots running from Main Street to the Commons on the southside, and from Main Street to the Millpond on the north side. The houses here at the bottom of New Way were demolished, having fallen into disrepair. Also to go was the town tip, the slaughterhouse, the tannery, the gasworks, smithy, various vehicle sheds, and the lake! The lake was created to try and address the ongoing problem of marshy land liable to flooding and a pair of swans was also in residence for many years. So too, however, were dozens of rats, and the population was gradually building.

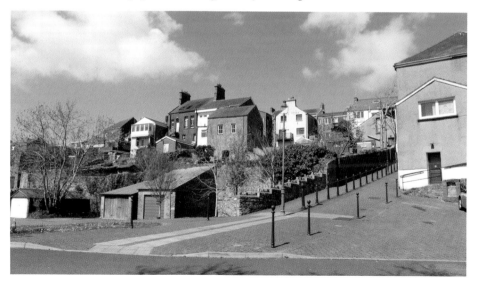

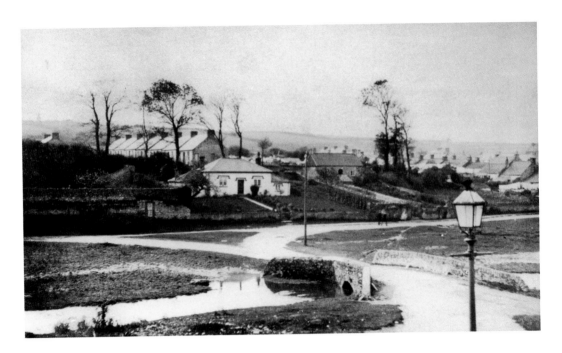

Pembroke Commons
This unusual postcard shows Primrose Cottage and Woodbine Cottage, and there was a third – Rose Cottage – out of sight on the left. In the distance to the right can be seen the rooftops of the Orange Gardens cottages. The quiet lane has been replaced by a busy road, which still follows the footpath of the old Commons Road. The tidal waters of the estuary would have reached here in centuries gone by, and even today the area still floods on occasion. Trees have been planted, attractive footpaths cross a stream that now meanders instead of the concrete-sided channel of earlier days, and a children's play area and good parking don't deter from the attractive and rural feel of this area so close to Main Street.

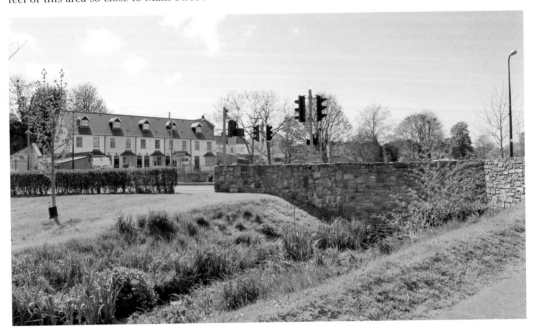

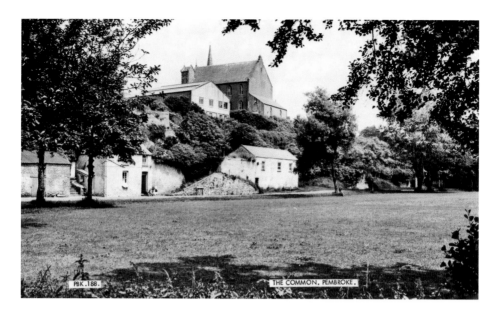

THE COMMON. PEMBROKE.

PBK.188.

A Gothic Tabernacle

A simple scene hides so much more. From the bottom of New Way to Gooses Lane in the distance, the town walls can be seen in all their various states of repair and disrepair. There is a limekiln to the right of the picture dating from the second half of the eighteenth century, and beyond that a medieval gun tower, one of the six towers originally situated along the walls. Internally, the tower had a spiral staircase, with the ground level inside being on a higher level, and no entry from outside the walls. It was built between 1218 and around 1320, and until the 1970s had a cannon on the roof, which mysteriously disappeared one night. Not far beyond these two buildings is a similar medieval tower topped by an eighteenth-century gazebo – again with an internal stair and possibly a stone vault. It is only from this spot that the sheer size and dominance of the Tabernacle United Reform Church can be appreciated, and its steeple can be seen from all areas of town, making it a very recognisable building.

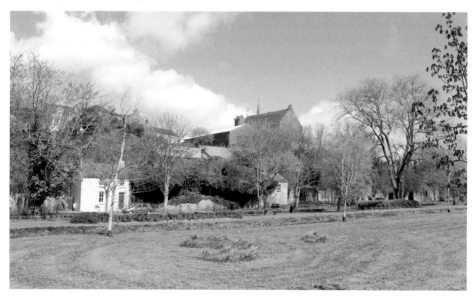

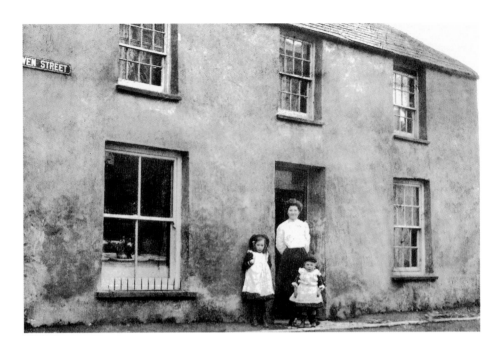

Orange Gardens – a Close Knit Community

Orange Gardens lies adjacent to Pembroke Commons to the south of the road that runs alongside it – Orange Way. Originally called Orange Town, it consists of several streets laid out in a grid system and filled with attractive cottages built in the 1860s by the Owen family at the height of their suspect election campaigning. A public house called the New Inn was included in the development, and was later renamed the Black Rabbit. The name is said to derive from a story about two local poachers and how they were caught. Orange Gardens was, and still is, a close-knit community with many families having lived there all their lives. The photograph above shows No. 1 Owen Street with Leticia Saunders (*née* Furlong) with her daughter Flossie and young son Norman, complete with dress and pinafore, as was the fashion for toddlers at that time.

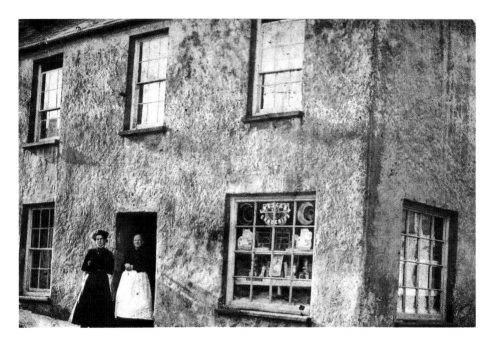

No. 2 Williamston Street – the Corner Shop

Florence Saunders is seen here standing with her mother outside their shop and bakery on the corner of Williamston Street in Orange Gardens. These little shops were an important part of a community and this one was no exception. Times were often hard, but people pulled together, and despite being a widow Mrs Saunders ran the little shop and also the bakery behind it in order to provide for her family. The shop would have had flexible opening hours and sold everything from candles to loose-leaf tea, hairnets to firelighters, and local butter for the home-baked bread.

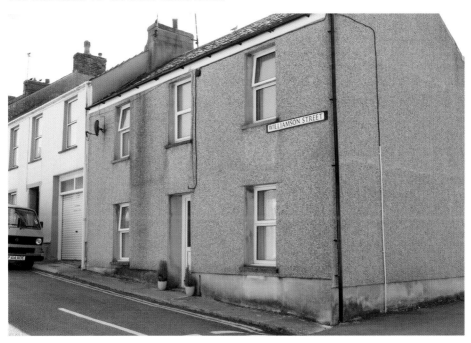

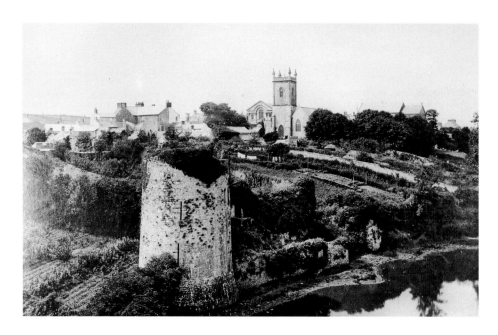

Barnards Tower – Garrison or House?

Barnards Tower lies just outside Pembroke's Town Walls, and would have led up to the Kennel Square (what we know today as East End Square), which lay just outside the Great East Gate at this important meeting of the ways. It is the best preserved of the six towers, being a large three-storey drum tower. It appears to have been designed to be lived in, with fireplaces, window seats, garderobe, a remarkable domed stone vault over the second floor and even possible evidence of a drawbridge pit. There are few features that can be accurately dated, but it is thought to have been built in the early 1300s. Today, the tower is a protected nursery roost for Daubenton bats (hence no access), which can be seen hunting for insects low over the Millpond waters at twilight throughout the spring and summer months.

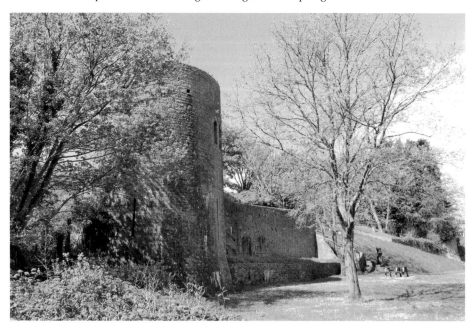

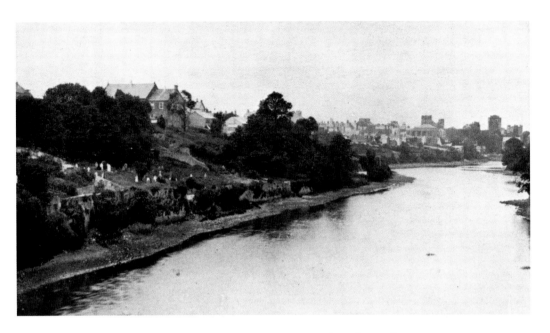

Once a Tidal Millpond, Today a Local Nature Reserve for All to Enjoy

For centuries, saltwater and tidal, then brackish, the Millpond today has been established as a freshwater system. It was designated Pembrokeshire's first Local Nature Reserve for enjoyment by locals and visitors alike. Otters are seen throughout the year, with lying up holts on the northern bank, and duck in winter, migrants in summer, cormorants, kingfishers, and bats galore are all there. The old town walls run the length of the Millpond from Millbridge to Barnards Tower. In the 1960s, enterprising councillors set out to create a Millpond walk with links to Main Street, and in 2012 a new Town Walls Trust was set up to develop a challenging and exciting project to make good the walls and raise the profile of Pembroke as a walled town. Uses will also be sought for some of the many burgage-plot gardens that open onto the Millpond walk through doorways in the walls.

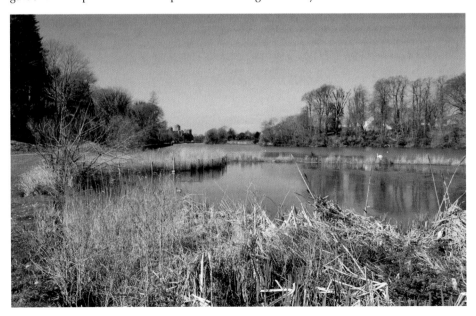

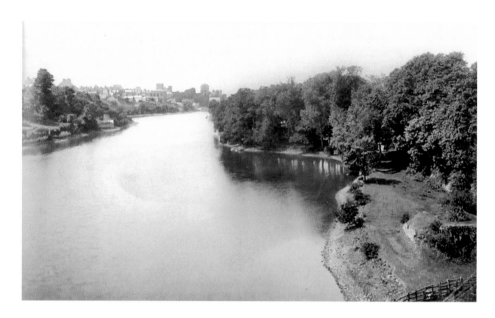

Otters Play Where French Prisoners Once Escaped

Taken from the top of the railway embankment – built to take the Pembroke and Tenby line into Pembroke Dock in 1863 – this image looks west towards the Millbridge. The embankment divided the old Millpond in half, creating an upper pond, which is now a Nature Reserve managed by the Wildlife Trust of South and West Wales. The remains of an old limekiln lie to the right of the photograph, and beyond the trees there is a small quay near Golden Farm. When the French landed at Fishguard in 1797 (blown off course on their way to Bristol) the result was the 'last invasion of Britain'. Pembroke yeoman soldiers were despatched, the 'renegades' were defeated with a little help from the local women dressed in red (thus looking like soldiers themselves, with Jemima Nicholas at their head) and the prisoners were brought to Golden Prison. Thirty of them made their escape, allegedly by digging a tunnel and with the help of two local girls and a boat.

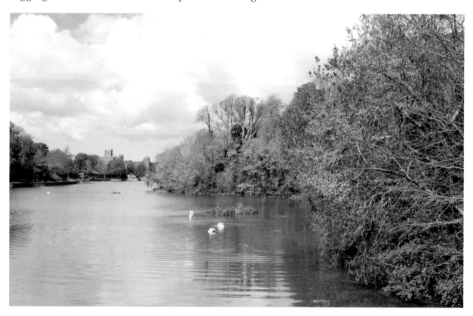

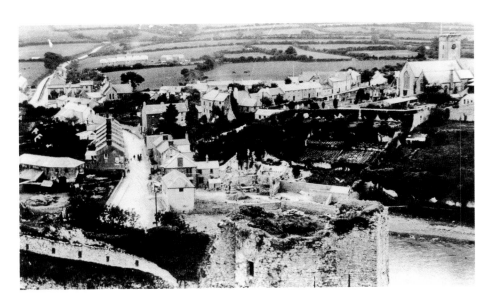

Old Monkton, an Early Christian Settlement

This excellent 1911 photograph, taken from Pembroke Castle's indomitable 98-foot tower, looks across Monkton Bridge to old Monkton. There was an early Christian settlement established there long before the Normans came, and finds made in a nearby cave established that early man (and sabre-toothed tigers) were here at least 5,000 years ago. In the centre of the photograph is Monkton Old Hall, possibly the oldest domestic house in Wales. Built around 600 years ago, it is thought to have been the Prior's House to nearby Monkton Priory with its farm and dovecote – now in private ownership. Sadly, many of the old cottages of Monkton were torn down in favour of a modern housing development, and with it much of the strong, close-knit community was fractured. Many, however, were happy to be rehoused in modern houses in The Green in Pembroke. The new development is now maturing and the school is thriving. Monkton's popular pubs have also now gone – the Dragon, the Salutation, Queen Vic and old Appletree amongst others, and the quay, where for centuries cargo ships would berth, trade and be fitted out, has now all but disappeared.

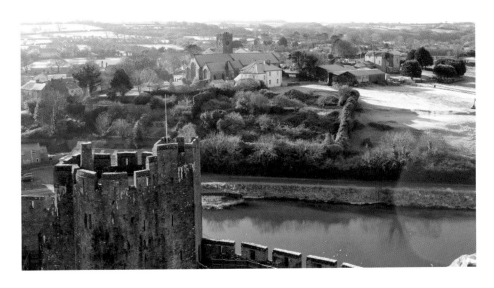

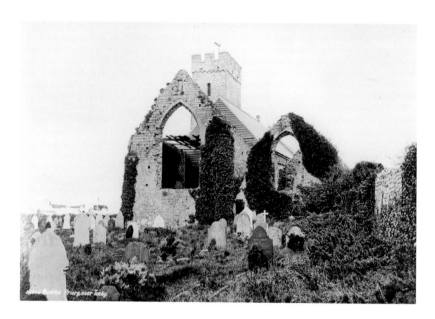

St Nicholas Church

When the Normans established their settlement and castle here in Pembroke, they also established a Benedictine Priory with its priory church dedicated to St Nicholas. The church fell into disrepair with the Dissolution of the Monasteries and by the late 1800s had become an ivy-clad ruin. In 1877, however, Revd David Bowen came to Monkton and, by 1882, had raised enough money to carry out restoration. Altogether, it took over seven years to complete, with a peal of eight bells added to the tower at the turn of the century. Freemasons donated further funds for the prior's private chapel and the stained-glass windows contain many masonic emblems. It has long been rumoured that a tunnel ran from the priory to Pembroke Castle (both stand on limestone with tidal waters between them) and during the restoration work, the skeleton of a man was found in a space above the porch, with hundreds of human bones found under the nave.

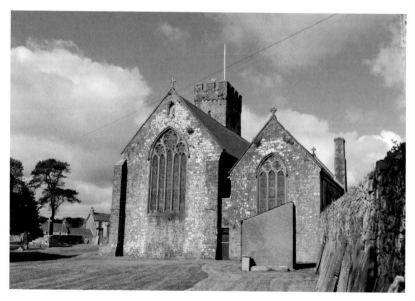

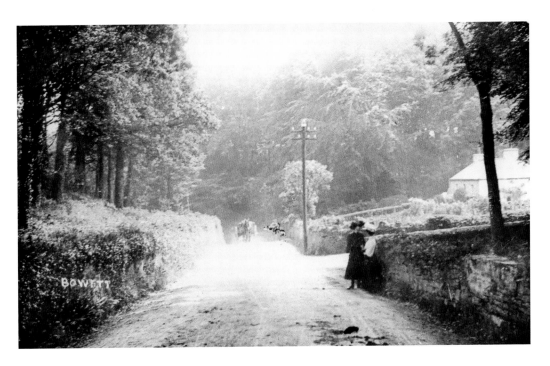

Posh Hats in Bowett Woods

Bowett Wood lies to the right of the lane here on the way from Hundleton into Monkton, with Quoits Wood on the left. Despite there being only a handful of dwellings nearby, the two ladies are elegantly dressed with remarkable hats. These, like many others, were working woods producing timber and goods to sell such as stakes for fencing. The cottage that lies behind the one in this photograph is called Square Island, one of several interesting names in the area. Other examples include Creature, Harry-stand-up, and Lightapipe. Half a mile away at Quoits Mill, where the dammed water still falls over a high dam top, Pembroke's first electricity was generated.

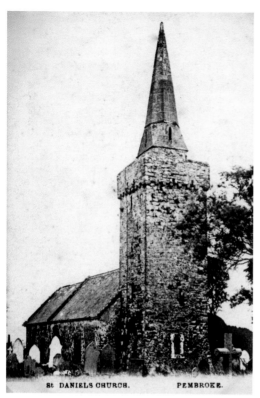

St DANIELS CHURCH. PEMBROKE.

St Daniel's Church
The church of St Daniel lies to the south of Pembroke at the top of St Daniel's Hill and it is rather special. The church is named after St Deinol – a hermit monk who lived there for several years in the fifth century, who built a cell where the church stands today, and founded the first place of worship there. It is claimed that many miracles took place while he lived above Pembroke, and that the waters from a nearby well were sacred. There is no trace of a spring in the area today, but it is known that St Deinol went on to become the Bishop of Bangor in North Wales.

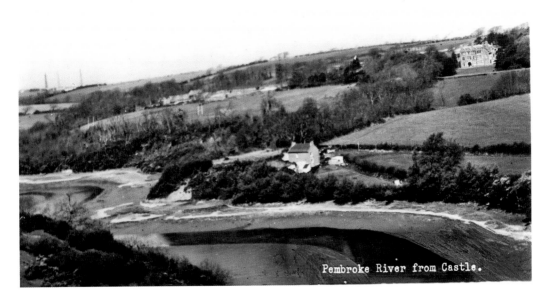

Pembroke River from Castle.

St Anne's Chapel, House and Wood

The John Speed map of 1610 names St Anne's chapel as being roughly in the centre of the scene above; however, its exact location it is not known. It was clearly an important place in its time and was named as a chapel of ease, with St Anne's footpath, St Anne's Wood, St Anne's Lane and St Anne's Villa all being nearby. It is very possible that the chapel had been on the site of the house seen above. All that remained of the house until recently has been levelled. Higher up is the imposing front of Bush House, and to the foreground today is 'The Barrage', which has effectively stopped boats from mooring at Pembroke quay – rather sad, though it has created a pleasant walk round the Castle Pond.

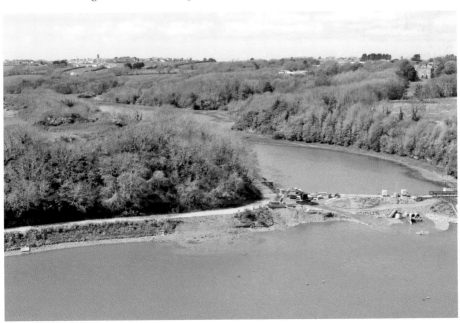

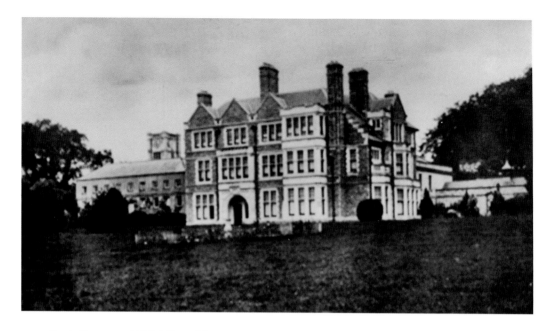

Bush House and Tidal Electricity

The Meyricks of Anglesey, who can trace their family tree back to the Welsh kings of North Wales, came to Pembrokeshire in the sixteenth century. In 1866, their impressive mansion just to the north of Pembroke Castle was burnt to the ground, causing £20,000 worth of damage. After the First World War, the much smaller Bush House of today became home to Sir Frederick Meyrick – a man well ahead of his time. In 1921 he read about a scheme intended to produce electricity by damming the Severn Estuary, and developed a similar scheme to dam the waters of Milford Haven. A barrage from Hobbs Point to Neyland, with a lock for ships, turbines, railway and road, would be built. The scheme was eventually taken seriously, and in 1959 the Milford Haven Tidal Barrage Bill was introduced to Parliament, but was opposed.

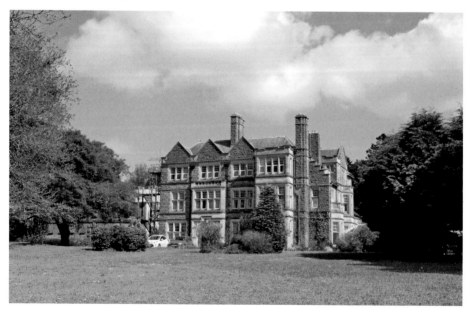

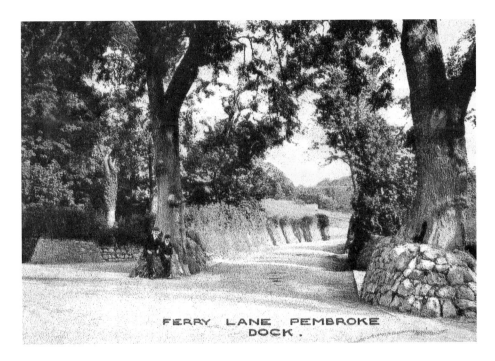

FERRY LANE PEMBROKE DOCK.

The Lane to the Ferry

The two magnificent trees shown in the postcard above were certainly still there at the beginning of the First World War. They were felled to make way for increasing traffic on the road since the development of the combustion engine in place of horse-drawn vehicles. Ferry Lane is far older than Pembroke Dock – indeed, there will have been a lane here for hundreds of years leading from Pembroke to Pembroke Ferry. The crossing from Pembroke Ferry to Burton on the other side of the Haven estuary was the closest crossing point for travellers on their way north.

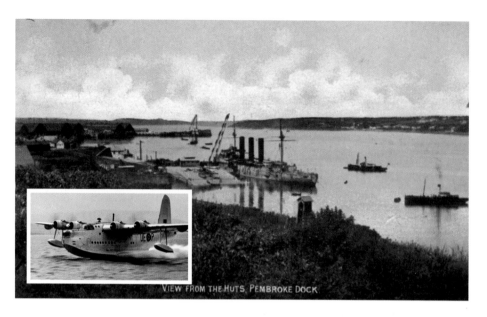

VIEW FROM THE HUTS, PEMBROKE DOCK

Pembroke Dock – Shipbuilding and Flying Boats

In 1814, the Admiralty decided to move their dockyard from Milford Haven on the opposite shore of the Haven estuary to Paterchurch, now named Pembroke Dock. There was no town or even a village then, and land was bought from the local gentry – the Adams, Meyricks and Owens. Within twenty years, a complete new town had been built on a grid system around the dockyard walls. Over 250 ships, mainly for the Royal Navy, were built in the dockyard, including four Royal Yachts. After the First World War, however, it was closed with terrible consequences for the town and its people – unemployment was rife. Virtually all of the town's economy was reliant on the shipbuilding and everything associated with it. By 1931, however, the RAF set up a flying boat base in the old dockyard and they remained there for nearly thirty years. A Sunderland Trust and museum with café have been set up to honour what became the biggest flying boat base in the world.

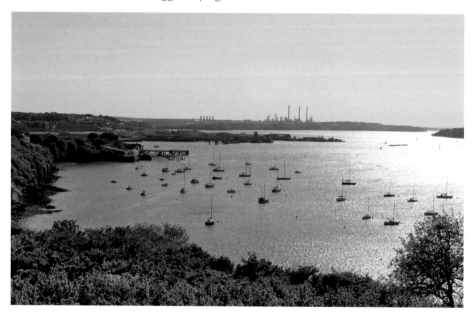

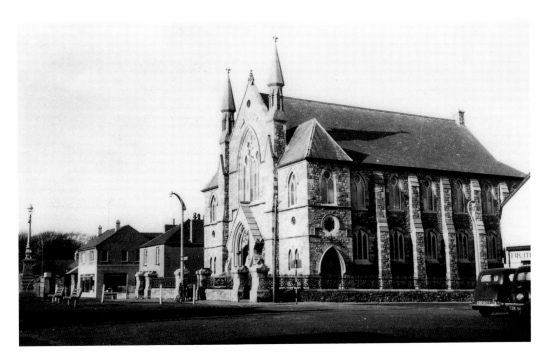

A Lost Chapel

By 1871, Pembroke Dock had a population of over 12,000 people. Church and chapel building also took place as congregations grew. Sunday schools were set up and well attended, reading and writing were taught, and attendance also ensured inclusion in any Sunday school outings. The impressive chapel in the photograph above was built on land that was once an orchard. It replaced a much smaller chapel of 1824 as the new town expanded. Albion Square Junior School was built on the opposite side of the square – both were closed some twenty years ago, with the once magnificent tabernacle building demolished in favour of a block of flats.

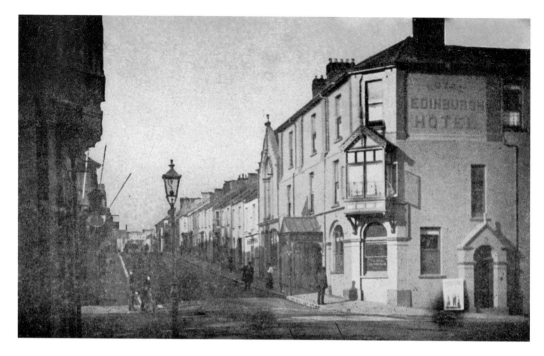

The Royal Edinburgh Hotel

The Royal Edinburgh had originally been called the Commercial Hotel, but was renamed in memory of the Duke and Duchess of Edinburgh, who launched the vessel of that name on 18 March 1882. Regarded as one of the finest hotels in the area, the Edinburgh Hotel, with its unusual first-floor corner bay window, lay directly along the road from the rail station. As recently as the 1980s, passengers could get on a train from as far away as Newcastle upon Tyne and not have to get off till they arrived in Pembroke Dock. In 1914, to commemorate the establishment of Pembroke Dock, it was the Royal Edinburgh Hotel that hosted a celebration lunch for the whole town.

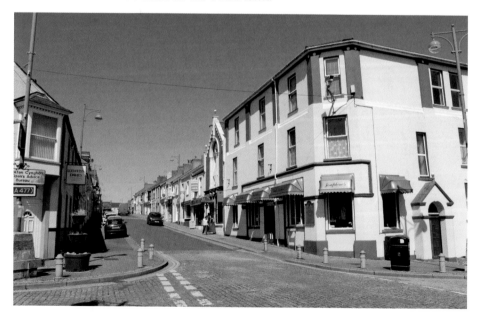

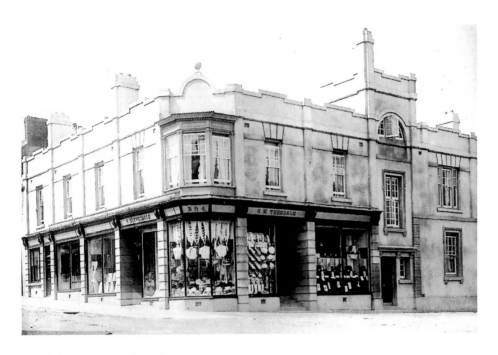

Teasdales – a Shop of Quality

When Joseph Hugh Teasdale bought his new shop, he named it London House and began trading as a linen, haberdashery and woollen draper, selling fine gloves and hats too. Joseph also became a Justice of the Peace and was the first president of the Pembroke Dock & Milford Haven Chamber of Commerce in 1882. When he died in 1899, he was the last person to be buried in Park Street Cemetery. According to Mrs Peters, who wrote much about Pembroke Dock, the firm of Teasdales was one of the first shops in the area to have gas lighting in the 1860s. It closed shortly before the Second World War. The building was demolished in 1956 and a convent for the Sacred Hearts of Jesus and Mary was built there a few years later. The convent closed in early 1990s and was redesigned as apartments with the name 'The Old Convent'.

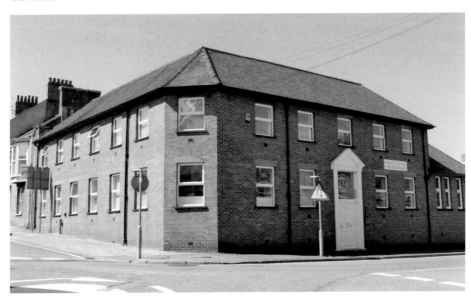

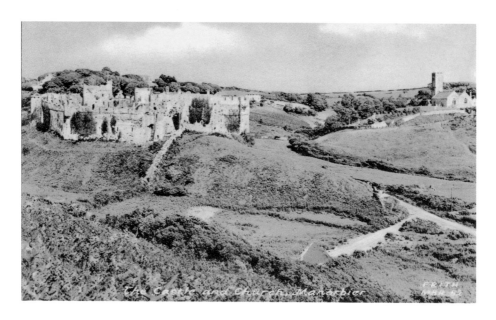

Magical Manorbier Castle

Built above the beach, popular with surfers today, Manorbier Castle's walls are some of the oldest in the country. Originally made of earth and timber, the first fortification was put up by Odo de Barri when the Normans established this south-west part of Pembrokeshire as their stronghold. Odo's son married Angharad, daughter of Welsh Princess Nest and Norman Gerald de Windsor, the castellan of nearby Pembroke Castle. Their son Gerald became an important chronicler of Wales and Ireland. Known as Gerald de Cambrensis or Gerald of Wales, his books are still highly readable today, and he wrote of Manorbier that, 'In all the broad lands of Wales, Manorbier is the most pleasant place by far.' The castle was further strengthened in case of attack by Owain Glyndŵr, and again when Cromwell was laying siege to Pembroke. Rowland Laugharn was living there at that time, and although he was captured and sentenced for his part in opposing Cromwell, he was later reprieved.

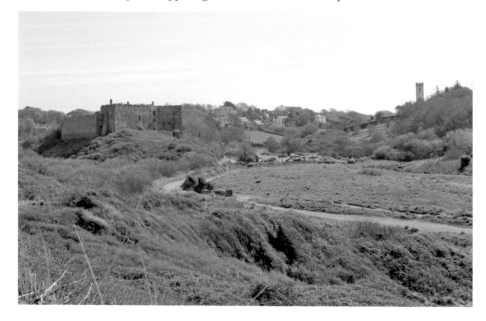

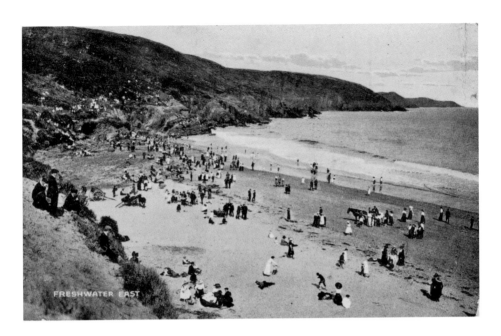

Freshwater East

Lying only 4 miles from Pembroke, Freshwater East is as popular today as it was almost 100 years ago. Before 1900, only a few farms and labourers' cottages were to be found in the area, but as business in town 'modernised', with the advent of the motor car, wooden bungalows were built in The Burrows – the dunes behind the beach. During the Second World War when Pembroke Dock with its air station, barracks and oil depot became an attractive target for the Luftwaffe, some families were able to retreat to these bungalows and experienced idyllic long summer days and the challenge of everything from storms, accidents and illness, to rats and mould through most of the year. The bungalows became ever more popular as summer chalets and verandas, gardens and a network of footpaths were established.

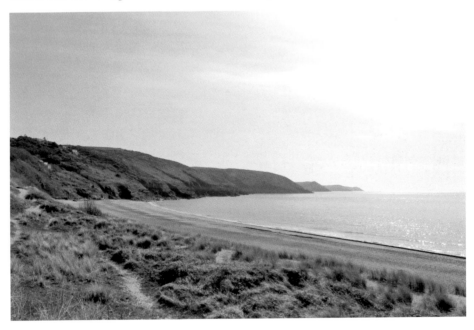

Stackpole Village

Lying close to Barafundle Bay, Stackpole Quay and the lovely Lily Ponds, Stackpole is a tranquil 'picture' village. In 1735, however, things were different. The village itself was moved from its original medieval site as extensive renovation, rebuilding and landscaping of grounds were carried out. It was primarily occupied by estate workers. Today, there is still a local school and a village pub with restaurant. The village church, Stackpole Elidor church, lies a mile or so away in the tiny hamlet of Stackpole Elidor, and was built in the thirteenth century or even earlier.

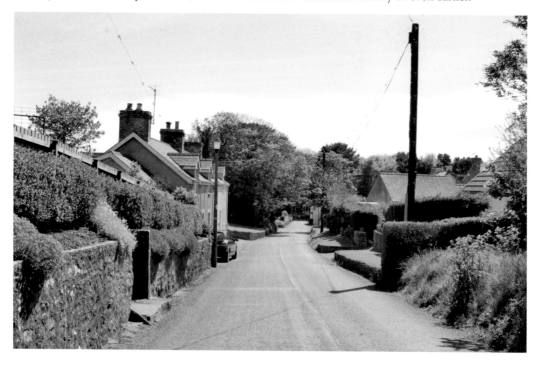

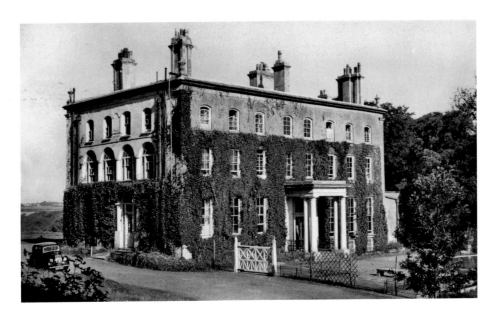

Orielton Estate and Political Ruin

From the time of Henry II when the Wyrriott family – and their ghost – were written about by Gerald of Wales, Orielton has been important and politically powerful. The house we see today is the third mansion, and is reputed to have a window for every day of the year. Around 150 years ago there was an American garden, Japanese garden, folly and gazebo, extensive fishponds and superb walled garden. For many years, the Owens of Orielton provided the Member of Parliament for Pembroke, but by the 1800s they were investing huge financial resources to ensure success. After a bitterly contested election with allegations of corruption, expenses were so crippling that first their land and properties and finally the mansion itself had to be sold in 1857.

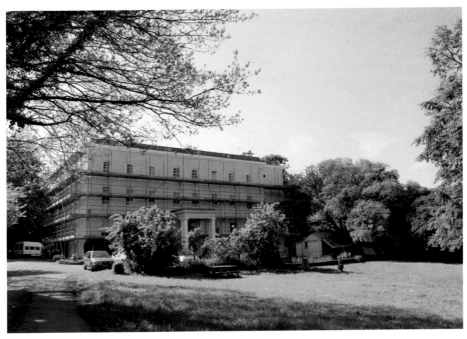

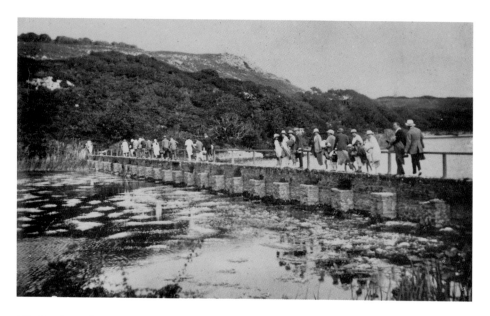

Lily Ponds and Lazy Days

In 1939, the War Office acquired a large portion of the Stackpole estate, which had stretched 10 miles from the village of Freshwater East to Freshwater West. Families and farm workers were evicted, the land became a firing range, and after the war German tanks and troops were shipped over every year for training, becoming very much involved with the local community as time went by. Today, the range lands are of international importance for vulnerable habitats and species, archaeology, lichens and much more. Not wanting to pay death duties, and frustrated that plans to turn the mansion, lakes and adjoining dunes, clifftops and woods into a holiday complex, and the 25th Thane of Cawdor razed the once great court to the ground. Edward VII stayed there in 1902 on his Pembrokeshire visit. The loss of the house proved to be the public's gain. The National Trust now manages the estate, with its many footpaths and superb views. Otters swim, pike lurk, swans glide and visitors still loiter on the narrow bridges as they cross on their way down to Broadhaven Beach.

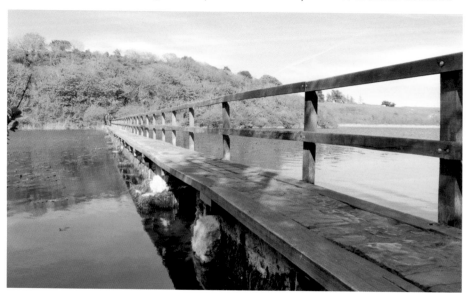

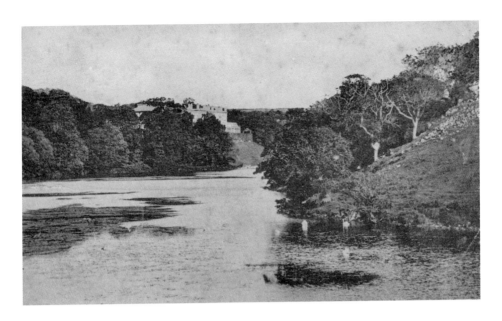

Stackpole Court

The lands and mansion of Stackpole became part of the Scottish Cawdor's estate in 1689, when Sir Alexander, MP and Lord of the Admiralty, married local heiress Elizabeth Lort. Their son, 'Joyless John', married another wealthy heiress, resulting in ownership of lands extending over 100,000 acres. An opulent 'new' mansion was built, lakes created in the valley below, and when it was realised that the little village of Stackpole could be seen on the horizon it was simply moved, further away and out of sight! For some 250 years the Campbells divided their time between Cawdor Castle near Inverness, London, Gelli Aur in Carmarthenshire, and Stackpole Court. The 700-mile journey here must have been daunting, especially for the children, but Pembrokeshire's mild winters and good life made it worthwhile. In 1963 the once-great house was demolished. Only the brewery and the stable block were saved, and today is the important home to a nursery roost of Greater Horseshoe bats. King Edward VII stayed here in 1902, and the family motto is 'Be Mindful'.

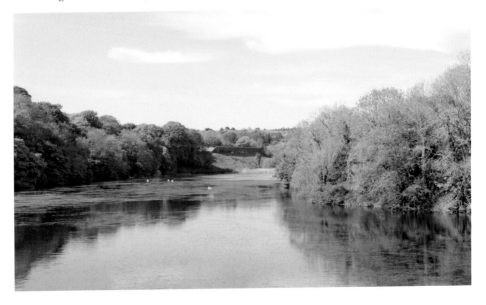

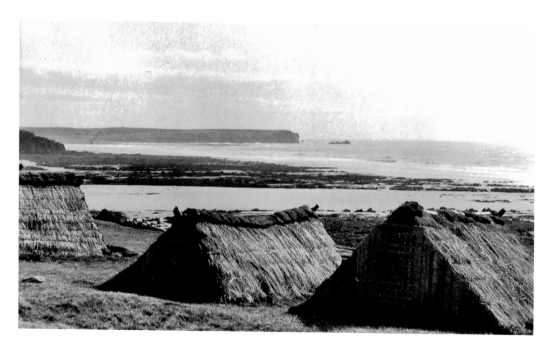

Seaweed Drying Huts at Freshwater West

The cottage industry of collecting laver weed in Pembrokeshire began during the eighteenth century. At Freshwater West, up to twenty drying huts could be found along the clifftop; each one was maintained by a local family – mostly from Angle. Ivor Wheeler from Pembroke and his wife were still collecting the long, stranded seaweed up until the 1970s. 'Laverbread' had become a staple food of pit workers in the eighteenth century as part of their breakfast. In 1865, George Borrow on his travels wrote of 'moor mutton with piping hot laverbread sauce', a popular dish of the time. Today, an enterprising local surfer has revived the tradition with a mobile beach café selling 'fruits of the sea'.

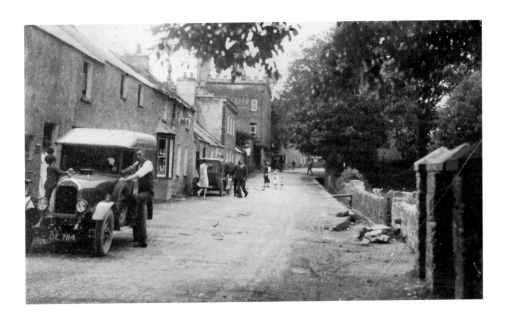

Angle Village

The Angle estate has been in the Mirehouse family for over 150 years, and at one time would have owned most of the houses in the village. Situated on a narrow peninsula at the very tip of south-west Wales, it has a strong seafaring tradition – there is a fisherman's chapel in the churchyard. There is a fourteenth-century pele tower, shop, school and pubs, and nearby are more historic buildings, the East Block Battery, Thorn Island Fort, and Chapel Bay Fort – soon to be open to the public. They were built after the Napoleonic Wars along with many other forts and gun towers right up the Haven. The attractive village stretches from east to west along a narrow road leading to the beach beyond. Today the village is as popular as ever, and many Pembroke families spend theit summer holidays there.

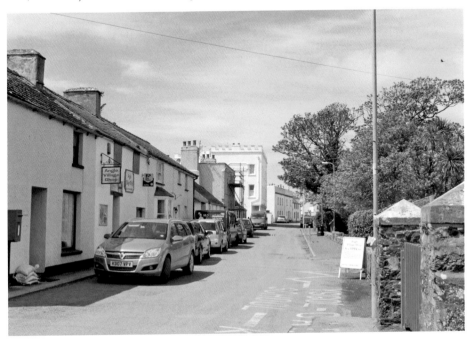

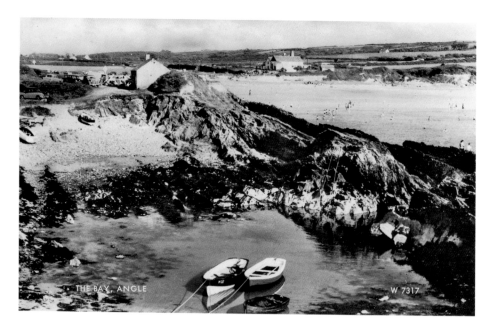

THE BAY, ANGLE W 7317

Rock Pools and a Sandy Beach

The rocks in the foreground of this picture are full of small fossils and rock pools, and the beach has been a favourite with families from Pembroke for eighty years or more. Behind the photographer lies stark Thorn Island with a small fort covering almost all of it, which became a hotel in 1947 and one summer was the magical venue for Shakespeare's *The Tempest*. The rocks beyond, however, can be full of treachery. One of the most famous shipwrecks in the area was in 1894 when the *Loch Shiel* went down with a cargo of whisky, gunpowder and beer on board. She was on her way from Scotland to Adelaide and had sought shelter. Much of the whisky was never recovered, having been spirited away by locals, and stories about it continue to this day. The other accident with huge repercussions was when the *Sea Empress* went aground in the Haven in 1996 nearby, spilling 72,000 tons of crude oil into the sea, which was devastating at the time.

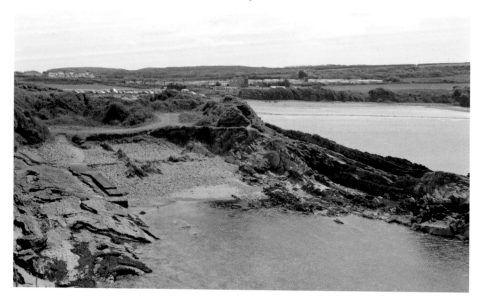

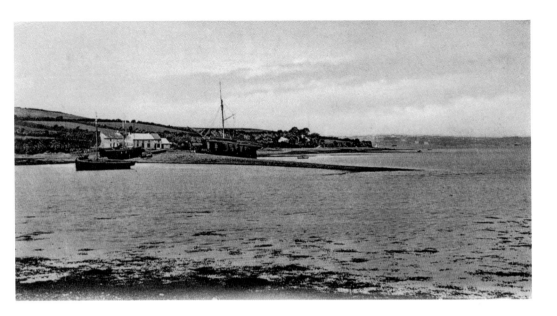

Angle Point House

The mooring of boats in this calm bay to the north of Angle village has been a place of safety for centuries. It has also been associated with shipwrecks and smuggling for as long as people can remember. The 500-year-old Point House pub lies at the end of an unmade road leading a half-mile or so from the village, and until a few years ago was legendary for having a coal fire in the little 'snug' that was never allowed to go out. The Angle lifeboat station is situated around the headland, facing out into Milford Haven, at a point where to the east the waters extend up to quiet backwaters of the two arms of the estuary, and to the south and west is the sea that in the past has bought invaders from many parts of Europe – all contributing to make Pembroke the excellent place it is today.

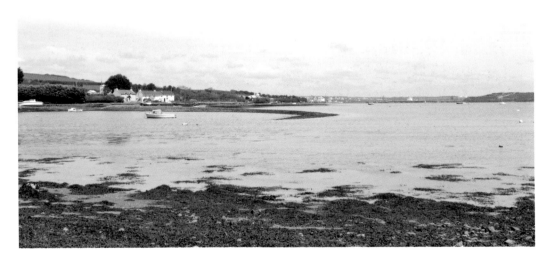

Haverfordwest Through Time

Patricia Swales Barker

This fascinating selection of photographs traces some of the many ways in which Haverfordwest has changed and developed over the last century.

978 1 4456 1614 8

96 pages, full colour